SYMBOLISM

JOSÉ PIERRE

SYMBOLISM

Eyre Methuen · London

Barron's · Woodbury, New York

Layout design by Jacques Douin

This translation first published
as a paperback original in Great Britain
in 1979 by Eyre Methuen Ltd,
11 New Fetter Lane, London EC4P 4EE,
and in the United States of America by
Barron's, Woodbury, New York

Translation by Désirée Moorhead

Originally published in France
© Fernand Hazan, Paris 1976
This translation © Fernand Hazan, Paris 1979
Reproduction rights reserved
S.P.A.D.E.M. and A.D.A.G.P., Paris

Printed in France by Sud-Offset, Rungis

ISBN 0 413 45900 4

All art is at once surface and symbol.
Oscar Wilde. **The Picture of Dorian Gray** (1891).

WHAT IS SYMBOLISM?

The poet Jean Moréas published the *Symbolist Manifesto* in the literary supplement of the *Figaro* on the 18th September 1886, thus giving rise to a judicious nomenclature of a tendency which had already been in evidence in French poetry for a good fifteen years but which reached its maximum intensity at that moment. Baudelaire's *Les Fleurs du Mal* of 1857 opened up new directions for what may henceforward be called Symbolist poetry whose first reaction was against such disorders of French Romanticism as its fatuity, excess of plangency and platitude. They reacted equally to the contrasting defaults of the Parnassians, to their craftsmanship, their impersonality and pomposity. Symbolist poetry reacted even more strongly against Naturalism as practised by Emile Zola who, trying to surpass certain initiatives of Flaubert, proposed only the saddest of cases as heroes and considered only the most banal, even the most sordid reality, of interest; a style which was resumed by Mallarmé under the term of 'reporting'. The young Symbolist poets were much influenced by Mallarmé even though the latter refused to undertake the role of a master (Verlaine was held in less renown and Rimbaud had to wait for the 20th century before his poet colleagues would seriously consider his work, while Lautréamont was more or less ignored).

This deepening awareness in poetry was dear to the Symbolists and they convinced themselves that this could be achieved even better if suggestion were substituted for description and metaphor for designation. The importance they accorded the occult had convinced them that there existed a secret harmony between nature and man and they enthusiastically adopted the doctrine of 'correspondences' which Baudelaire had borrowed from the Swedish theosophist, Swedenborg (1688-1772). They paid careful attention to the analogous relations between the sonority of words and colours or scents. Nobody went further in this direction than the hero of Huysman's *A Rebours*, des Esseintes, who built an organ of liqueurs, thanks to which he was able 'to play inner symphonies and to procure in the gullet sensations similar to those which music pours into the ear'. Against the advice of Mallarmé and with the intention of applying poetic discourse to the most fluent emanations of thought, dream, daydream, 'spleen' and nostalgia of every kind the poets decided to break with strict poetic form and to compose in free verse. On the one hand the use of free verse and on the other the emphasis given to evocative sounds showed the relation of Symbolist poetry to music (a summit meeting of the two arts occurred in 1902 with the production of *Pelleas and Melisande*, the opera by Maurice Maeterlinck and Claude Debussy) while other 'correspondences' favoured painting and it seems to be in the pictorial domain that the symbol, allowed to assume form and colour, is most easily readable. In spite of what is frequently said, it can be maintained that painting was a more important means of expression for Symbolism than music and that Symbolist painting played the same role as Surrealism for the visually illiterate in that it could translate into quickly accessible visual terms a thought which otherwise could only be absorbed by study of books or magazines.

However artists were not awaiting the outcome of the poets' reaction against traditional values – quite the contrary. Indeed today it has been decided that the appearance of a typically Symbolist manner in painting outstripped by far that of Symbolist poetry which, according to the varying generosity of some so-called specialists, extends either over a period of five or six years or else over the interval between the 1870-1871

Franco-Prussian War and the outbreak in 1914 of the First World War. This already constitutes an irrefutable proof that, contrary to an idea which is fairly current, painting was in no way an illustration of Symbolist poetry – it did however share identical aspirations which were evident in the work of the painters before they appeared in that of the writers. Furthermore the exhibition, 'European Symbolism', which travelled around Western Europe from November 1975 to July 1976, took the year 1848 as a point of departure, being the year of the founding of the pre-Raphaelite group in London, and today the following are generally believed to be the immediate precursors of Symbolist sensibility in painting: in England, Johann Heinrich Füssli (1741-1825), William Blake (1757-1827) and William Turner (1775-1851); in Germany, Caspar David Friedrich (1774-1840), Phillip Otto Runge (1777-1810) and Carl Gustav Carus (1789-1869); in Belgium, Antoine Wiertz (1806-1865); in France, Theodore Chassériau (1819-1856), Charles Meryon (1821-1868) and Rodolphe Bresdin (1825-1885). It is clear that from the beginning of the 19th century right through to the beginning of the 20th century Symbolist painting was not an infinite repetition of similar themes and forms but a continuous search carried out with certain plastic options which were revealed one after another and which with some variants can be resumed in three principal formulas. Whatever were the differences between these formulas and between the artists who practised them it is certain that all of the Symbolist painters were violently opposed to the maxim of Gustave Courbet whereby 'painting is a completely physical language composed of all of the visible objects'. Also what opposed them to Realism and Naturalism (we have already seen this with the poets) opposed them to Impressionism of which Gauguin in a typical Symbolist remark said: 'They seek not in the mysterious centre of thought but in the immediately visible'.

THE PRINCIPAL PHASES OF SYMBOLIST PAINTING

If, by opposition to Realism, Naturalism and Impressionism, pictorial Symbolism can also be identified, as it has frequently been, as Idealism it then becomes possible to speak of *Hyperrealist Idealism* which has its first appearance in the mid-19th century in the work of the pre-Raphaelites. The apparent contradiction between noun and adjective may surprise as may the reference to hyperrealism, a mode which comes to us via the U.S.A., but the paradoxical ambition of the English pre-Raphaelites (in particular that of William Holman Hunt and John Everett Millais) was to partner what they considered to be extremely noble thoughts with a technique of an almost fanatical exactitude which owed quite a debt to photography. The advantage of such a technique when used to describe historic or legendary events, or better still episodes of religious history, was that it conferred an astonishing credibility on the figures involved as to their actions and gestures. How could one doubt the veracity of Ophelia, of the sorcerer Merlin or of Christ when confronted by their coloured photograph on a canvas two metres high which revealed the least unwanted hair or beauty spot? Victorian England was greatly shocked by this technique, particularly when applied to matters of religion. The pre-Raphaelites did not hesitate to position figures of the Old and particularly of the New Testament in a banal and everyday

context of very precise description. The intention was not at all derisive but more probably intended to diminish the distance between their contemporaries and early Christian times and also to help recall the more plebeian complexion of their beliefs (William Morris who played an important role in the adaptation of the minor arts to the pre-Raphaelite aesthetic was a convinced militant socialist). Using Italian painting prior to Raphael as a reference, that is Fra Angelico to Masaccio and Mantegna to Botticelli, the pre-Raphaelites tried to regain a freshness which had been waylaid and to oppose the academic traditions of the Cinquecento of da Vinci, Michaelangelo and Raphael which had influenced the art of the past three hundred years. Dante Gabriel Rossetti and Edward Burne-Jones were the most strongly affected by this backward glance at the Quattrocento but such a reference is also significant in the nostalgia for an art 'before sin' which is common to nearly all avant-garde movements who seek their justification in a historic past – as, before the pre-Raphaelites, was the case with the Nazareens, those Germans who established themselves in Rome in order to try to rediscover there the secret of medieval religious painting – or a distant geographic location (Japan in the last quarter of the 19th century; Negro art at the beginning of the 20th century and Amerindian and Oceanic art with the Surrealists).

Pre-Raphaelite Hyperrealism had a wide influence in Europe and gave rise to many original vocations – in England such was the case with George Frederic Watts – but it also engendered many pale imitations bordering on caricature. This second category was typical of the heyday of the Rosicrucian Salons from 1892 to 1897. These were organised by Joséphin Pédalan (1859-1918) a singular personage typical of the end of the century esotericism who in such a manner endeavoured to 'bring the joys of spirituality and of pure mysticism to a profance world wallowing in materialism'. According to Pédalan himself the star of the Rosicrucian Salons was none other than Fernand Khnopff who through a faithful interpretation of a photograph was able to present a work of exceptional order and gravity, the poetic qualities of which are again very close to our

own present values. Attention should also be given to another variant of this current issuing from pre-Raphaelism which can be called *Academic Idealism* in which a less detailed use of technique and less precise visual portrayal allows the memory of classical painting to overtake the example of photographic reality: in this sense one could speak of a Post-Raphaelism. The most notable interpreters of this trend included Puvis de Chavannes, Hans von Marées, Eugène Carrière and Max Klinger, all of whom were innovators but innovators not entirely freed from the art of museums and as a consequence not freed from academic tradition which however did not prevent von Marées and particularly Puvis de Chavannes from giving a lesson of rigorous plastic organisation of the surfaces of their large solemn compositions – a lesson which would be important for the younger generations. Carrière's reputation during his lifetime was considerable and may surprise us now but it stemmed from his offering the public 'realities having the magic of dreams' as Jean Dolent wrote of his work in 1885. Max Klinger was probably the strangest of these four artists and in his graphic work which made him a master of gravure of the 19th century he expressed the oddest of intuitions as can be seen in his well-known series, *Paraphrase on the Discovery of a Glove* (1881).

At the moment when Impressionism became a coherent force around 1870 two painters were reaching their peak of maturity. Totally dissimilar, one from the other, their work could be classified under the hypothetical heading of *Baroque Idealism*. The painters in question were Arnold Böcklin and Gustave Moreau. They were undoubtedly familiar with the pre-Raphaelites but their temperaments were not in harmony with the formal precision of the British artists. Moreau was also attracted by the art of the Quattrocento and knew it well as the result of a long stay in Italy (1856-1860) but in his own work this influence was counterbalanced by the example of the Baroque painters, in particular by Rembrandt and also by the baroque Romanticism of Delacroix. Böcklin's sometimes dashing manner drew him closer to the Venetians but he also gave proof of a vigour akin to Courbet but to a Courbet whose only ambition was not solely to render 'all of the visible objects'. Even more than a particular sensuality of touch, what associates Böcklin and

Moreau (more evident in the work of the Basle Master than in that of Moreau) is a similar attitude to the presence of myth. Since the Renaissance had imposed the illustration of Graeco-Latin mythology on Western painting, it was the first time that such a singular resurrection of the mythical substratum of Antiquity was seen as depicted in the work of these two forceful sensibilities, who took as their point of departure into an investigation at once aesthetic, psychological and philosophical what before had been used simply as a pretext for exercises of mechanical virtuosity. For his part Gustave Moreau used the Greaco-Latin myths as a mirror for his own preoccupations which revolved around what can be called the war of the sexes. This is probably why he so often painted the many charades of Jupiter, particularly those in which the god avails himself of animal disguise in order to seduce Leda, Europe or Pasiphae. Böcklin on the contrary celebrates the minor divinities of the sea and forest and through them seems to encourage us to permit free rein to our instincts as they alone are able to keep us in harmony with the forces of nature which were given form by the Romans and Greeks in an effort to disguise their abstraction and to render them more conciliatory. A visit to Pompeii in 1862 had convinced Böcklin of the pitiless fight which opposes man to nature, a fight rendered even more hopeless when man loses contact with his natural environment. As a result we have war or plague and in such images Böcklin anticipated the great ecological scare of our time.

Such baroque vehemence is also present in the work of Henry De Groux and Félicien Rops although now it is puzzling to remember the extent to which the public admired their art or maybe it was their corrosive qualities that pleased. Odilon Redon and James Ensor pose different problems: the former on account of the contrast between the intended nightmarish and sombre inspiration of his 'blacks' and the free, chromatic effusion of his pastels and oils from around 1895; the latter was prone to alternating bouts of good humour and confusion in his everyday life and works, in which he veered between sarcasm, ecstasy, anguish and jubilation but the fact remains that both painters are authentic practitioners of baroque Symbolism. Impressionism as used by Henry Le

Sidaner and Henri Fantin-Latour may owe something to baroque Idealism but it was above all the neo-Impressionists who were interested in Symbolist afterthoughts. It was obvious that Seurat was open to such thinking and his doctrine was clearly founded on the theory of 'correspondences' although he employed a 'very physical language' and made use of a more scientific manner of work than that practised in the school of Monet and his followers. This was also the case with such interesting artists as the Belgian Théo von Rysselberghe; the Dutch Johan Thorn Prikker and Jan Toorop and particularly the Italians Giuseppe Pelizza da Volpedo, Gaetano Previati and Giovanni Segantini. In Italy neo-Impressionism was for a long time synonymous with the avant-garde and all three artists played an important part in the double light of symbol and of 'simultaneous contrast'. Several of the artists mentioned had been influenced by the pre-Raphaelites but nearly all of them would feel the backwash from the real revolution inherent in the formula 'synthetism' when it was introduced to Symbolist expression.

This formula of 'synthetic' Idealism, which was worked out in 1888 by Paul Gauguin and Emile Bernard at Pont-Aven, constituted, thanks to Gauguin's genius, the ideal vehicle in the plastic translation of Symbolist thought under its mythical, mystical and oniric aspects which after all were its most characteristic. The Symbolist poets were quite aware of this and two of the youngest among them, Albert Aurier and Charles Morice, recognised in Gauguin's *Vision After the Sermon* the equivalent for painting of what Moréas' *Symbolist Manifesto* had been two years previously for poetry. What Emile Bernard had previously called 'cloisonnism' was an approximate explanation of the 'synthetic' formula. As in stained glass, form is enclosed by a strong arabesque which defines zones of pure colour organised in flat planes. This involves the suppression of depth and therefore of perspective and the resultant pictorial space is described in the two dimensions of the canvas. To this must be added the instructions given by Gauguin to Paul Sérusier when he painted his famous *Talisman* in the Bois d'Amour near Pont-Aven in the same year, 1888. 'How do you see these trees? They are yellow. Well, paint them

yellow. The shadow is more or less blue, paint it in a pure ultramarine and paint the red leaves in vermilion'. Seventeen years later such advice would be sufficient for the Fauves but not for the Symbolists. The Fauves like the Impressionists did not look into 'the mysterious centre of thought but in the immediately visible'. The arbitrariness of colour was explained by Gauguin not only for aesthetic reasons but as much to reveal conclusions as to the theme undertaken by the painter as to the intimate relations of the painter to the theme. Such a manner of work ignored the real and three dimensional space in which we move and the intense colour was rather that of dream and of desire than that which we perceive in everyday life, but as a result Gauguin's work had access to the same possibilities and desiderata of poetry as defined by Mallarmé in 1894: 'Poetry, which is the human language reduced to its innate rhythm, is the expression of the mysterious sense of existence; it imparts an authenticity to our earthly sojourn and constitutes the one spiritual task'. If from its beginnings the overall design of Symbolist painting was, as in the words of Paul Klee, 'to render visible the invisible' but by 'invisible' implying the world of sentiment and thought, rather than an improbable mass of gods and spirits (which from a certain point of view was a wholly materialistic ambition), then from the pre-Raphaelites to Böcklin and Puvis de Chavannes this was carried out in the manner of traditional European painting. Gustave Moreau, followed by Odilon Redon, showed more daring in the order of plastic invention but neither succeeded in disassociating themselves completely from the weight of the past and of the history of art. On the other hand Gauguin with his 'synthetic' formula proposed a radically new organisation of the canvas and of its relation to the visible or invisible world. Perhaps it is necessary to add that it is not at all important that the formula in question resulted from reflections on such widely differing examples as medieval art, popular Japanese prints, the Epinal prints, Egyptian art, Javanese art or Polynesian art but what was important was to succeed in the 'synthesis' of all this and to make it the privileged instrument of Symbolist expression at the end of the 19th century. The immediate repercussions were considerable both in the domain of painting proper as well as in the minor arts which underwent a great upheaval. Gauguin's followers at Pont-Aven or at Pouldu (with

the exception of Filiger) were not great painters any more than the Nabis (with the exception of Felix Vallotton). Edvard Munch however was a colossus of the same spirit as Gauguin and in his hands the 'synthetic' formula reached its full pathetic dimension in which its graphic and chromatic intensity, contrary to Gauguin, was not used to seek a Paradise lost but rather to portray the gamut of inner anguish. Far from contradicting each other Gauguin and Munch complement one another as do the pangs of desire and the satisfaction of the same.

Synthetic Idealism also had its eccentrics who, carried away by the heady alcohol of the flat plane and the hashish of the arabesque, brought the formula to an incandescent pitch and demonstrated how it could lend itself to either the most tawdry or the most sublime treatment. Aubrey Beardsley in England, Hans Schmithals, Carl Strathmann and Heinrich Vogeler in Germany, Karel de Nerée tot Babberich, Thorn Prikker and Toorop in Holland, Konůpek and Váchal in Bohemia illustrated in their respective ways these extremes of 'synthetism' which seem relevant today in our world which is so torn between its need of spirituality and its accesses of violence. Ferdinand Hodler, Gustav Klimt and Felix Vallotton figure among the great Symbolist painters and despite their evident differences they share a common ground in that they also found a 'synthesis', but one midway between 'the formula of Gauguin and certain naturalistic preoccupations.' What distinguishes all three comes from this cocktail of abstraction and trivial reality whose proportions had been carefully calculated by each artist, confident that they held the recipe of a potentially explosive mixture. Even though the work of such precursors as William Morris and Walter Crane must be taken into account (it should not be forgotten the extent to which they remain tributaries of Pre-Raphaelism), it was essentially *Synthetic Idealism* that accounted for the sudden popularity of Art Nouveau. Freed from its obligations of defining areas of colour in Gauguin's work, the arabesque was now given free and indiscriminate rein to decorate facades of houses, furniture, ornaments, wallpaper, materials, Métro stations, lamps, womens' clothing and millinery, mantlepieces, mirror frames, books,

street posters and probably even the pedestrians themselves. And it must be mentioned what a veritable revolution then took place in the graphic arts, from poster designers of genius such as Toulouse Lautrec, Mucha, Bradley, the Beggarstaff Brothers, Ludwig Hohlwern, and others, to the pleiad of incomparable illustrators, amongst whom, without doubt, it is fitting to reserve the first place for one Arthur Rackham. The eruption was on an international scale and spared nowhere from Chicago to St. Petersburg, from Stockholm to Naples and that some people decided to call a halt seems very likely.

This resumé of successive movements of the Symbolist offensive in the pictorial domain would not be complete if it did not include the fact that spiritism was widespread from the mid-19th century and therefore the entire Symbolist movement is imbued with stories of 'spirits' which, tapping or not, caused many a table to turn. Spiritism would be of little interest in this book if it were not for the fact that early on some mediums used the spiritualistic trance to induce the production of texts, drawings, prints and paintings. The results of this can be called *Spiritualistic Idealism* and the early works are contemporary to the first pre-Raphaelite paintings. The diversity of style is remarkable in that it corresponded to the same possibilities offered by Symbolist painting from the slightly weighty figuration of the pre-Raphaelites and their successors in the Rosicrucian Salons to the excesses of floral and frenetic abstraction of Art Nouveau and of some extremists of the 'synthetic' persuasion. From the famous Nancy glass-maker Emile Gallé and from Rossetti to Mucha a common ground is not lacking between what can be called 'professional Symbolist' painting and work produced in a trance-like state whether automatic or simply idealistic, and whereas the former is taken seriously and given due consideration the latter continues to be looked at in a less serious light. Some works which are quite meritorious in their own right but difficult to place in the three previous categories really find their inspiration in this *Spiritualistic Idealism* as can be seen in the ecstatic character of their style and inspiration. This is notably the case of William Degouve de Nuncques and of his fantastic nocturnal landscapes

and later his visions of Majorcan grottoes, also of Alberto Martini with his illustrations for the stories of Edgar Allan Poe and paintings such as *Twilight Butterfly* (1912) and Lucien Lévy-Dhurmer (the greater part of whose work however was in the colder vein of pre-Raphaelism) in dream landscapes such as *My Mother, One Evening, Saw the City of Ys* (circa 1897).

THE OUTCOME OF SYMBOLISM

Böcklin said that 'a painting should say something, should provoke thought as does a poem or should leave an impression like a piece of music on the spectator'. Such a proposition would have been seconded without hesitation by the Symbolist painters because they were all in agreement with the principle of 'correspondences' and because they shared Symbolism's wish to aspire to a harmony between all the arts, a wish dear to William Morris, and even to realise the total work of art as envisaged by Richard Wagner – *Gesammtkunstwerk*. This attitude was fundamentally opposed to that of other artists and aesthetes who argued the contrary theme that each branch of the arts should cultivate its own singularity and distinguish itself radically from other forms of expression (hence Paul Cézanne would be the only artist of the time who managed to withstand the seductions of Symbolism). Here we find two quite irreconcilable positions: that of the Symbolists and later on the Surrealists who demanded more profound meaning, and that which permitted no other meaning to painting than, as in Maurice Denis' famous definition, 'a flat surface covered by colours which have been organised in a particular manner'. Of course every time the second position is in favour it tends to regard the former with extreme disdain even to the point of trying to eliminate it historically. With its cohorts of sphinxes, chimeras,

trembling virgins, mystical ecstasies, rampant lilies and heavenward glances, Symbolist painting can be overpowering, but the other camp also had ad nauseam its stonemasons, beer drinkers, women washing their feet, regattas at Argenteuil, St. Victoire mountains, pipes on occasional tables, Rumanian blouses, squares and rectangles. In the end it is possible that we find ourselves confronted by the eternal reproach administered to a person who flaunts tradition by the defenders of a simplistic rationalism close to that of Courbet that 'an invisible abstract object is not part of the domain of painting'.

A classic example of polemic consists of linking the names of people already in disgrace to others even more outside the pale. In this way the enemies of Symbolist painting deliberately linked the latter to the bemedalled and beribboned official artists of the 19th century known today as 'pompiers' (i.e. artists of rigid academic leaning). In all fairness such a deliberate association is unjust and ignores the fact that the pre-Raphaelites caused as much scandal as Delacroix and that Gustave Moreau was hardly better received than Manet and Gauguin found it as difficult as Monet to sell his work. It is true that some of the 'pompiers' rediscovered today share with certain pre-Raphaelites and other exhibitors at the Rosicrucian Salons a fondness for narrative, and when looking at their works it is difficult to make up one's mind if the story which comprises the theme is Symbolist at all. Theoretically narrative painting can be supposed to be one which restricts itself to illustrating a period of history or literature from legendary times until today, while Symbolist painting on the other hand, even that which seems like straightforward narrative, intended the suggestion of a second or hidden sense in the manner in which the episode was depicted (which is the reason why the 'synthetic' formula represented a summit of Symbolist expression significant from its very inception). Apart from its chocolate-box appeal, Millais' *Ophelia* (1852) is firstly an illustration from Shakespeare's *Hamlet* but can also be seen as a representation of madness or in the third instance as a reflection on death or again a suggestion as to the state of grace which would allow man to renew his links with nature. The thesis that a Symbolist work contains more than the painter's original

intentions can also be considered! An examination of Symbolist painting poses the question of the differences between allegory and symbol and the young Symbolist poet, Albert Mockel, responded in the following terms: 'Allegory, like symbol, translates the abstract by concrete means. The two procedures are founded on analogy and the two contain an image. However I would define allegory as a product of the human spirit in which the analogy is artificial and exterior while in Symbolism it is natural and intrinsic. Thus allegory is an explicit representation and is analysed by means of an image, of an abstract idea. It is also a conventional representation of this idea with its steorotyped attributes as either gods or heroes. Symbolism on the contrary implies an intuitive research of latent ideas through particular forms' (1894).

Gauguin explained the above in a more concrete manner in his well-known dictum: 'Puvis explains his idea, yes, but he does not paint it; he is Greek while I am a savage, a wolf without a collar. Puvis calls his work *Purity* and to explain it paints a young virgin with a lily in her hand (the description corresponds precisely to a painting of Puvis de Chavannes entitled *Hope* of which Gauguin had pinned a reproduction on the walls of his Tahitian hut); a symbol like that is easy to grasp. Gauguin with a title like *Purity* would paint a landscape of limpid water'. These words illustrate the marked evolution of allegory towards symbol during the 19th century and also in a more general fashion the transformation of what may be called *Manifest Symbolism* from a less doctrinaire stance to a deeper inner search for truth which may be designated under the heading of *Latent Symbolism*. The pre-Raphaelites, Puvis de Chavannes and Gustave Moreau did not show much interest either in portraiture or in landscape but a change came about in these areas (probably due to the influence of Friedrich and Samuel Palmer in landscape and in portraiture from the example of Chassériau) and it was then possible to talk of the Symbolist portrait and of the Symbolist landscape. The practitioners of such works included Degouve de Nuncques, Gauguin, Hodler, Khnopff, Klimt, Lévy-Dhurmer, Munch, Pelizza da Volpedo, Preisler, Sohlberg, Spilliaert, Vallotton and Whistler. With the change in fashion and the passing of time several of these artists abandoned the exterior forms of

Manifest Symbolism and treated their portrait and landscape in the manner of *Latent Symbolism*. Some superficial observers have decreed that this was a renunciation of Symbolism but in reality it was symptomatic of a more intrinsic and deepening awareness. There were few defections in the ranks of Symbolist painters and they remained faithful to their convictions in a quiet and unpublicised way so that in any case Symbolism with its love of mystery and of the unknown would not have lost out.

A series of mutations brought Symbolism into the first fifteen years of the 20th century. From the example of Ensor, Munch, Hodler, Vallotton, Klint and Spilliaert the expressionist mutation came about fairly early on and it is easy to recognise what the leaders of the *die Brücke* group (founded in Dresden in 1905) owe to the Symbolists, in particular Ernst Ludwig Kirchner, Erich Heckel and Emil Nolde. The same can be said of the *der Blaue Reiter* group founded in Munich in 1911 which included Franz Marc and August Macke and in Vienna, Oscar Kokoschka. The Fauvist movement lasted only a short time and its nomenclature is an example of flagrant exaggeration because its adherents were in reality the less flamboyant disciples of *The Talisman* (executed by Sérusier under Gauguin's directions in 1888). With the advent of Cubism it seemed that 'Cézanne's gang' was ready to liquidate 'Gauguin's gang' altogether but it should not be forgotten that Pablo Picasso, the principal brain of the new movement, had painted one of the masterpieces of latterday Symbolism in 1906, *Woman with Fan*, and that his subsequent 'Negro period' came as much from the Gauguin of *The House of Pleasure* as the African artefacts of the Trocadero Museum. The Symbolist imprimatur is in evidence at the beginnings of Italian Futurism, Giacomo Balla, Umberto Boccioni, Carlo Carrà, Luigi Russolo and Gino Severini having been influenced by the neo-Impressionist works of Previati, Pelizza de Volpedo and Segantini. Marcel Duchamp showed his interest in the example of Odilon Redon in several works of 1911 such as *Breeze on the Japanese Appletree: About the Young Sister*. Giorgio de Chirico was strongly influenced by Böcklin and by 1910 he was producing excellent paintings of a dream-like atmosphere whose debt to Symbolism was

never in doubt and which the Surrealists later considered as expressing the very matter of painting. However they found the key to their specific originality in the automatism of *Spiritualistic Idealism*. The mutation of Symbolism to Abstraction is one of the most interesting and took place in the work of Wassily Kandinsky, the most interesting artist of the 20th century. He rediscovered the virtues of the expressive subjectivity of *Synthetic Idealism* and in one quick stroke he was able to detach the arabesque from its duty of banking up fields of colour thus allowing painting to concentrate 'on the real functioning of thought'. Between 1910 and 1914 this metamorphosis was confirmed by the researches of several other artists among whom Franz Kupka is one of the most interesting. Casimir Malevitch and Piet Mondrian were surely subjected to the spread of the idealist virus and it can be claimed that hardly any movement of 20th century art does not owe something to the example of Symbolism.

DEFENCE, ILLUSTRATION
AND CRITICISM OF SYMBOLISM

POETIC SYMBOLISM

DEFINITIONS

Ennemie de l'enseignement, de la déclamation, de la fausse sensibilité, de la description objective, la poésie symboliste cherche : à vêtir l'Idée d'une forme sensible qui, néanmoins, ne serait pas son but à elle-même, mais qui, tout en servant à exprimer l'Idée, demeurerait sujette.

> **Jean Moréas,**
> *Manifeste du Symbolisme,* 1886.

Le symbolisme ?... comprends pas... Ça doit être un mot allemand... hein ? Qu'est-ce que ça peut bien vouloir dire ? Moi d'ailleurs je m'en fiche. Quand je souffre, quand je jouis ou quand je pleure, je sais bien que ça n'est pas du symbole.

> **Paul Verlaine,**
> *Réponse à l'enquête de Jules Huret,* 1891.

Nommer un objet, c'est supprimer les trois quarts de la jouissance du poème qui est faite du bonheur de deviner peu à peu ; le *suggérer,* voilà le rêve. C'est le parfait usage de ce mystère qui constitue le symbole : évoquer petit à petit un objet pour montrer un état d'âme, ou, inversement, choisir un objet et en dégager un état d'âme, par une série de déchiffrements.

> **Stéphane Mallarmé,**
> *Réponse à l'enquête de Jules Huret,* 1891.

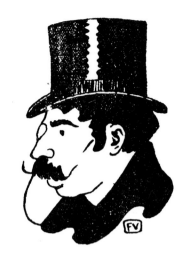

Vallotton. Portrait of Moréas.

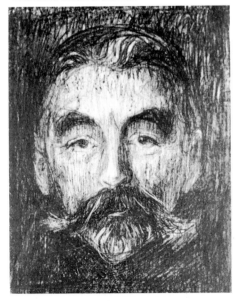

Munch. Portrait of Mallarmé. 1896

La Nature est un temple où de vivants piliers
Laissent parfois sortir de confuses paroles ;
L'homme y passe à travers des forêts de
 [symboles
Qui l'observent avec des regards familiers.

 Charles Baudelaire,
 Correspondances (les Fleurs du mal, 1857).

SOMMEIL ! — Loup-Garou gris ! [SOMMEIL !
 Noir de fumée !
SOMMEIL ! — Loup de velours, de dentelle
 [embaumée !
Baiser de l'Inconnue ; et Baiser de l'Aimée !
— SOMMEIL ! Voleur de nuit ! Folle-brise
 [pâmée !
Parfum qui monte au ciel des tombes
 [parfumées !
 Tristan Corbière,
 Litanie du sommeil (les Amours jaunes, 1873).

A noir, E blanc, I rouge, U vert, O bleu :
 [voyelles,
Je dirai quelque jour vos naissances latentes.

 Arthur Rimbaud,
 Voyelles (publié en 1883).

Les Princesses aux yeux de chevreuil passaient
A cheval sur le chemin entre les bois.
 Dans les forêts sombres chassaient
 Les meutes aux sourds abois.

Dans les branches s'étaient pris leurs cheveux
 [fins,
Des feuilles étaient collées sur leurs visages.
Elles écartaient les branches avec leurs mains,
Elles regardaient autour avec des yeux
 [sauvages.

 Paul Claudel,
 le Sombre Mai, 1887.

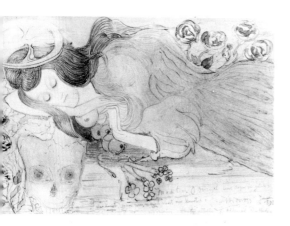

Toorop. Agressivité du sommeil. 1898.
Private Collection.

Ayez pitié des regards de la vierge tentée !
(Oh ! des fleuves de lait ont fui dans les
⎡ténèbres !
Et les cygnes sont morts au milieu des
⎡serpents !)
Et de ceux de la vierge qui succombe !
Princesses abandonnées en des marécages
⎡sans issues !
Et ces yeux où s'éloignent à pleines voiles
⎡des navires illuminés dans la tempête !

> Maurice Maeterlinck,
> *Regards (Serres chaudes,* 1889).

Tel le clapotis des carpes nourries
 A Fontainebleau
 A des voix meurtries
 De baisers dans l'eau.

> Alfred Jarry,
> *Madrigal* (publié en 1903).

Onde vraie,
Onde première,
Onde candide,
Onde lys et cygnes,
Onde sueur de l'ombre,
Onde baudrier de la prairie,
Onde innocence qui passe,
Onde lingot de firmament...

> Saint-Pol-Roux,
> *Sur un ruisselet qui passe dans la luzerne*
> *(De la colombe au corbeau par le paon,* 1904).

J'ai trois fenêtres à ma chambre :
 L'amour, la mer, la mort,
Sang vif, vert calme, violet.

O femme, doux et lourd trésor !

> Charles Cros,
> *Hiéroglyphe (le Collier de griffes,* 1908).

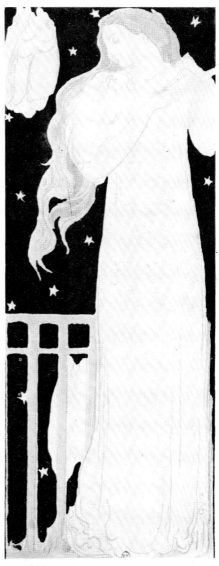

Denis. Illustration for
La Demoiselle Élue by Maeterlinck.

Là-haut, la nuit énorme
S'ouvre et recule,
S'élargit comme un geste harmonieux,
Beau rêve qui précise
La forme redoutée des dieux...

Francis Vielé-Griffin,
Sapho (la Lumière de Grèce, 1912).

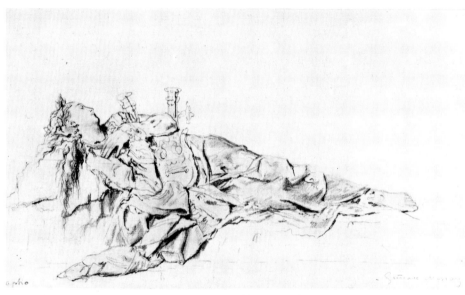

Moreau. Sapho. Musée Gustave Moreau, Paris

PICTORIAL SYMBOLISM

inner eye. A work springs from confused emotions in which it lies like an embryo in an egg. I nurse the thought which is lying in this emotion and cherish it until it becomes as clear as possible. Then I look for the context into which I can translate it with all possible precision… I suppose that if you like is Symbolism.

Puvis de Chavannes.

Puvis explains his idea, yes, but he does not paint it. He is Greek while I am a savage, a wolf without a collar. Puvis calls his work

Pre-Raphaelitism has but one principle, that of absolute, uncompromising truth in all that it does, obtained by working everything, down to the most minute detail, from nature, and from nature only.

John Ruskin

We declare that art should show mankind that the world is much more beautiful not only in each natural form but also in every principle of a pure life and that without the help of art they will not see this. If a work of art nonplusses and tends to deny that there is a design in creation and no wisdom in evolution then our humanity is a poor thing.

William Holman Hunt.

A portrait is not art.

Arnold Böcklin.

Every clear idea can be translated by a plastic thought. However we are usually the recipients of mixed-up and disordered ideas and it becomes necessary to redefine them before they can be seen in their original shape by the

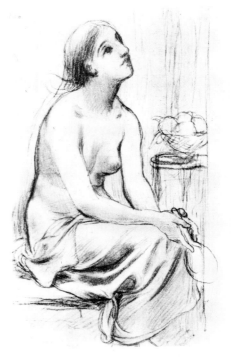

Puvis de Chavannes. Young Woman Holding a Mirror. Musée du Petit Palais, Paris.

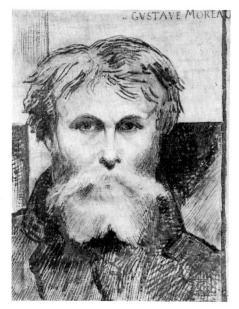

Moreau. Self-portrait.
Musée Gustave Moreau, Paris.

Khnopff. By the Sea. 1890

Purity and to explain it paints a young virgin with a lily in her hand: a symbol like that is easy to grasp. Gauguin with a title like *Purity* would paint a landscape of limpid water.

Paul Gauguin.

That which predominates in my work is the pulse and ardour which brings it close to abstraction. The expression of human sentiment and passion does interest me but I am less given to portraying such states of soul than to making visible those inner inspirations which seem to emerge from nowhere but possess something of the divine and which open magical horizons when translated by purely plastic means.
What does nature matter in itself? It serves as a pretext for the artist... Art is an untiring pursuit of inner meanings expressed through plastic terms.

Gustave Moreau.

Art should make the subjective objective.

Fernand Khnopff.

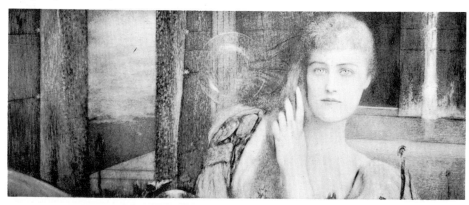

My originality lies in my ability to make unlikely beings live following the laws of the likely and in applying as much as possible the logic of the visible to the service of the invisible.

Odilon Redon.

A work of art should be of ideas as its one ideal is the expression of ideas: it should be Symbolist because it expresses this idea through forms; 'synthetic' because it expresses these forms after an accepted manner of thinking; it should in the end (it is a consequence) be decorative.

Albert Aurier, 1891.

The Rosicrucians wanted to destroy Realism and they rejected all military, patriotic, anecdotal, oriental, rustic and sportive scenes. On the other hand they were in favour of subjects of Catholic dogma, the interpretation of oriental Theogony, decorative allegories and subliminated nudes.

First Rosicrucian Salon, 1892.

Remember that a painting before it turns into a war horse, nude woman or whatever, is essentially a flat surface covered by colours which have been organised in a particular order.

Maurice Denis, 1890.

The artist will find the really serious work in the innermost depths of his being: there he is undisturbed by the murmur of the stream, the chatter of the birds and the whisper of the leaves.

Giorgio de Chirico, 1913.

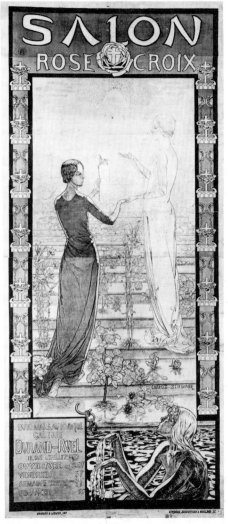

Schwabe. Poster for the Rosicrucian Salon 1892

Kandinsky. Xylographie. 1907

Gustave Moreau: *Salome* (Salon of 1876).

The Salome of Gustave Moreau springs from quite another Testament and in her des Esseintes finally recognised the superhuman and strange Salome of whom he had dreamed. She was more than just a passer-by drawing cries of desire and lust from an old man moved by the venial swing of her hips; with the swell of her breasts, the movements of her belly and the shake of her thighs she crushed the energy and broke down the will of the king. She became in some way the symbolic deity of indestructible lechery, the goddess of immortal Hysteria, the damned Beauty singled out by a catalepsia which stiffens the flesh and hardens the muscles; such a monstrous Beast as the Helen of old, indifferent, irresponsible, insensitive and dangerous to all who approach, see or touch her.

> **Joris-Karl Huysmans,**
> *A Rebours*, 1884.

Pierre Puvis de Chavannes:
The Poor Fisherman, 1881.

A clearly delineated figure fishes from a little boat; on the river-bank a child lies among yellow flowers near the figure of a woman. What does the title mean? Is this man really a poor fisherman or a happy fisherman and when does the event occur? It is a twilight painting as in an old frescoe invaded by the light of the moon, by the sweeping rain; colour changes from lilac to white, from pale milky green to light grey; in its naif rigidity it is hard, dry and touching. Confronted by this painting I shrug my shoulders. I am annoyed by this idiocy of biblical dimension, obtained by the sacrifice of colour to the

Moreau. Profile of Salome.
Musée Gustave Moreau, Paris.

delineated contours whose angles are emphasised by a pretended primitive awkwardness. At the same time I experience pity and indulgence because it is the work of one led astray but also that of a dedicated artist who ignores the caprice of the public and who, contrary to some of his colleagues, refuses to descend into the gutters of fashion.

> Joris-Karl Huysmans,
> *Modern Art*, 1881.

Paul Gauguin: *Manao Tupapau:
The Spirit of the Dead Keeps Watch*, 1893.

The wall already sleeps.
Olympia lies
dark on the perch
of golden arabesques
shading and profaning
her diaphanous body,
the disappearing sun,
pale gold of her couch,
dream of olden mysteries:
of solitary nights
soul of the sleeping dead
reviving lovers.
May their wraith-like arms
may their numberless arms
this wanton night
of emerging incubus
clasp my virgin body!

> Alfred Jarry,
> *ManaoTupapau* (Three poems after and
> for Paul Gauguin, published in 1948).

Jean Toorop: *The Three Brides*, 1893.

It is of almost monastic devilment: three women draped in gauze shrouds like Spanish madonnas appear in a larva-filled landscape, fluid, undulating and vomitous like a mass of leeches: *The Three Brides*, the betrothed of the Sky, the betrothed of the Earth and the betrothed of Hell. The latter has two snakes writhing on her forehead and restraining her veil. She is the most attractive, has the most alluring eyes and the most vertiginous smile imaginable.

> Jean Lorrain,
> *Monsieur de Phocas*, 1901.

OPINIONS OF SYMBOLIST PAINTING

The **artist** – above all the painter – who looks inwards is a god. But the painter who looks only outward is no better than an ape.

Saint-Pol-Roux
> (published in 1961).

(On the pre-Raphaelites).

How disappointing! Their art is intelligent, noble, subtle, full of ideas and of finesse and has a rare imaginative quality but the end results are deceptive. What coldness and poverty! What misery and what pretentious use of colour! What a bric-a-brac is offered by this pictorial literature in which the beauty of the story depicted serves to weaken even more the interpretation we are given!

> **Henri de Regnier,**
> *(The Review of Two Worlds,*
> *la Revue des deux Mondes, 1925).*

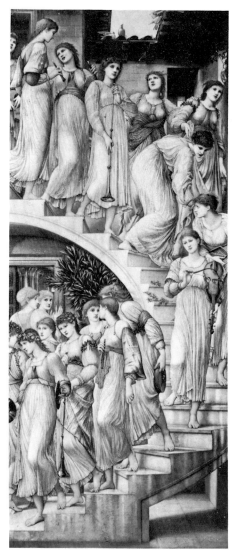

Burne-Jones. The Golden Ladder.
1876-1889, The Tate Gallery, London.

Redon. Cavalier en fuite.
Rijksmuseum Kröller-Müller, Otterlo

This painting is evidently the only one which is faithful to Rimbaud's wish for a language which would be 'from the soul to the soul'. At its best we can only experience a fleeting sensation from the other and this work is to the other what poetry in its strictest sense is to the prose of the best seller or to journalistic meanderings.

André Breton
On Symbolism, 1958.

Mr Odilon Redon draws an eye on the end of a stalk which wanders in an amorphous landscape. You will be told that this eye represents the eye of conscience while others see it as the eye of uncertainty. Some say it represents an eye synthetized into a sunset on the hyperborean seas, others believe it to symbolise universal suffering, this 'bizarre Waterlily' swims in the black waters of invisible Acherons...

Octave Mirabeau,
The Gaulois, 1886.

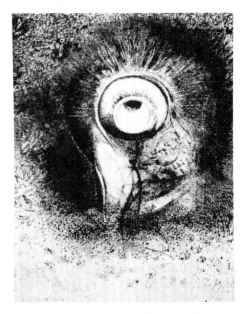

Redon. Il y a peut-être une vision première essayée dans la fleur. 1883

Mr Fernand Khnopff and a number of his fellow exhibitors at the Rosicrucian Salon will never understand that the aim of a painting should be founded on rhythm and that a painter shows an excess of humility in choosing a subject which is already rich in literary significance, that three pears spread on a tablecloth by Paul Cézanne are moving and sometimes mystical and that all the Wagnerian Valhalla is as lacking in interest as the Houses of Parliament if painted by them.

Felix Fénéon.

Courbet had the right idea when he laughed loudly at the discussion of soul but all the same he displays more soul in a square centimeter of his most earthy paintings than can be found in the reunited works of the English pre-Raphaelites, of Gustave Moreau or of Böcklin.

Elie Faure.

We have seen enough of coral reds: let them be blue! One of the essentials of Art is the New. Without it is to be as a vertebrate without vertebra and Art would dissolve and resemble the remains of a jellyfish thrown upon the sand by the tide. Of all the theories on Art which have been bandied about these latter days only one appears to be really new and new of hitherto unknown and unseen novelty. This is Symbolism – when cleansed of the outrageous significance imposed on it by shortsighted minds it is literally translated by the word Liberty or on the part of the violent by the word Anarchy.

Remy de Gourmont
The Revue Blanche, 1892.

I discovered the Gustave Moreau Museum at the age of sixteen and it entirely conditioned my way of loving.
André Breton,
preface to *The Fantastical Art of Gustave Moreau*, by Ragnar von Holten, 1960.

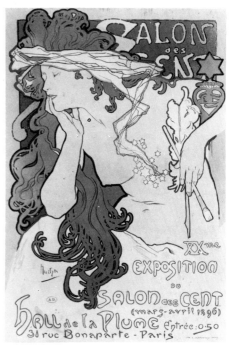

Mucha. Poster for the Salon of the One Hundred. 1896

Note:
Amongst the quotations above, some are borrowed from Philippe Jullian's *Esthètes et Magiciens* (Librairie académique Perrin, 1969), others from the anthology of symbolist poetry accredited to Bernard Delvaille (Seghers, 1971). *A Rebours* and *Monsieur de Phocas* were recently reissued in the collection 10/18. The quotations from Breton come from the 1965 edition of his work *le Surréalisme et la Peinture* (Gallimard)

CHRONOLOGY OF POETIC
AND ARTISTIC SYMBOLISM

1845
Birth of Walter Crane

1846
Birth of Emile Gallé and Isidore Ducasse.

Death of Haydon.

1847
Beginnings of spiritism in the U.S.A.

1848
Pre-Raphaelite Fraternity founded in England.

Birth of Paul Gauguin, Joris-Karl Huysmans and Louis Comfort Tiffany.

1849
Death of Edgar Allan Poe.

Birth of Eugène Carrière.

1850
Rossetti: *Ecce Ancilla Domini.*

1851
Death of William Turner.

Holman Hunt: *The Bad Shepherd.*

Birth of Ernst Josephson, Arthur Heygate Mackmurdo and Germain Nouveau.

1852
Birth of Antoni Gaudi and of Gaetano Previati.

Millais: *Ophelia.*

1853
Birth of Ferdinand Hodler and of Vincent Van Gogh.

1854

Death of John Martin.

Holman Hunt: *The Light of the World*.

Birth of Arthur Rimbaud.

1855

Death of Gérard de Nerval.

Pre-Raphaelites exhibited at the Universal Exhibition in Paris.

Madox Brown: *The Last of England*.

Birth of Alexander Séon and Emile Verhaeren.

1856

Death of Théodore Chassériau.

Birth of Jean Lorrain, Jean Moréas and Michael Vroubel.

1857

Baudelaire: *Les Fleurs du Mal*.

Birth of Max Klinger and Alphonse Osbert.

1858

Birth of Fernand Khnopff, Victor Prouvé, Albert Samain, Giovanni Segantini and Jan Toorop.

Millais: *The Vale of Rest*.

Morris: *Queen Guinevere*.

1859

Death of Marceline Desbordes-Valmore.

Birth of Edmond Aman-Jean, Derkinderen and Gustave Kahn.

1860

Birth of James Ensor, Jules Laforgue, René Lalique, Alphons Mucha and Giulio Aristide Sartorio.

1861

Death of Francis Danby.

Birth of Charles Doudelet, Ludwig von Hofman, Aristide Maillol, Saint-Pol-Roux, and Ludwig von Zumbusch.

1862

Death of Elizabeth Siddal.

Birth of René Ghil, Gustav Klimt, Maurice Maeterlinck and Théo van Rysselberghe.

1863

Death of Alfred de Vigny.

Hughes: *Home from the Sea*.

Rossetti: *Beata Beatrix*.

Birth of Charles Filiger, Stuart Merrill, Edvard Munch, Hermann Obrist, Franz von Stuck, Henry van de Velde, Jens Ferdinand Willumsen.

1864

Moreau: *Oedipus and the Sphynx*.

Birth of Paul Ranson, Henri de Régnier, Paul Sérusier, Francis Vielé-Griffin.

1865

Death of Antoine Wiertz.

Madox Brown: *Work*.

Birth of Otto Eckmann, Emile Fabry, Axel Gallén-Kallela, Melchior Lechter, Georges Lemmen, Lucien Lévy-Dhurmer and Félix Vallotton.

1866

Rossetti took up spiritism.

Birth of Wassily Kandinsky, George Minne, Charles Ricketts, Carlos Schwabe and Carl Strathmann.

1867

Death of Charles Baudelaire and Jean-Dominique Ingres.

Birth of Pierre Bonnard, Frank Brangwyn, Degouve de Nuncques, Jean Delville, Henry De Groux, Hector Guimard, Thomas Theodor Heine, Emil Nolde, Marcel Schwob, and Arthur Rackham.

1868

Birth of Peter Behrens, Emile Bernard, Will Bradley, Paul Claudel, Georges de Feure, Georges Lacombe, Charles Rennie Mackintosh and Johan Thorn Prikker.

1869

Count de Lautréamont: *The Songs of Maldoror*.

Birth of André Gide, Margaret Macdonald, Jozef Mehoffer, Giuseppe Pelizza da Volpedo, Armand Seguin, Stanislaw Wyspianski.

1870
Death of Isidore Ducasse, Count de Lautréamont.

Birth of Alexander Benois, Maurice Denis and Pierre Louÿs.

1871
Birth of Giacomo Balla, August Endell, Frantisek Kupka, Marcel Proust and Paul Valéry.

Puvis de Chavannes: *Hope*.

Rossetti: *Dante's Dream*.

1872
Watts: *The Sower of the Systems*.

Birth of Henry Bataille, Aubrey Beardsley, Paul Fort, Bernhard Pankok, Jan Preisler and Heinrich Vogeler.

1873
Corbière: *The Yellow Loves*.

Cros: *The Sandalwood Trunk*.

Pater: *Studies in the History of the Renaissance*.

Rimbaud: *A Season in Hell (Une saison en enfer)*.

Birth of Alfred Jarry.

1874
Millais: *The North-West Passage*.

Birth of Bruno Paul.

1875
Death of Tristan Corbière.

Birth of Rainer Maria Rilke.

1876
Mallarmé: *l'Après-midi d'un faune*.

Moreau: *Salome* and *The Apparition*.

Birth of Jessie King and Alberto Martini.

1877
Burne-Jones: *The Beguiling of Merlin*

Redon: *In Dream*.

Whistler: *The Peacock Room. Nocturn in Black and Gold*.

Birth of Alfred Kubin and Gabriele Münter.

1878
Birth of Léon-Paul Fargue and Hans Schmithals.

1879
Birth of Witold Wojtkiewicz.

1880
Böcklin: *The Island of the Dead*.

Birth of Guillaume Apollinaire, Ernst Ludwig Kirchner, Franz Marc and de Nerée tot Babberich.

1881
Death of Samuel Palmer.
Klinger: *Paraphrase on the Discovery of a Glove*.

Puvis de Chavannes: *The Poor Fisherman*.

Birth of Carlo Carrà, Pablo Picasso and Léon Spilliaert.

1882
Death of Dante Gabriel Rossetti.

Crane: *The Wheel of Destiny*.

Birth of Umberto Boccioni and Edmond Dulac.

1883
Death of Richard Wagner.

Grasset: illustrations for *The Story of the Four Sons of Aymon; Most Noble and Valiant Knights*.

Birth of Felice Casorati.

1884
Huysmans: *A Rebours*.

Burne-Jones: *King Cophetua and the Beggar Maid*.

Mackmurdo: frontispiece for *Wren's City Churches*.

Birth of Amedeo Modigliani.

1885
Death of Rodolphe Bresdin and Victor Hugo.

Watts: *Hope*.

1886
Death of Richard Dadd.

Ghil: *Treaty of the Verb*.

Moréas: *Symbolist Manifesto*.

Rimbaud: *Illuminations*.

Birth of Oskar Kokoschka.

1887
Death of Jules Laforgue and Hans von Marées.

Burne-Jones: *The Baleful Head*.

Birth of August Macke and Saint-John-Perse.

1888

Death of Charles Cros.

Gauguin: *Vision after the Sermon*.

Sérusier: *The Talisman*.

Birth of Giorgio de Chirico.

1889

Death of Barbey d'Aurevilly and Villiers de l'Isle-Adam.

Maeterlinck: *Hothouses* (illustrated by George Minne).

1890

Hodler: *Night*.

Seurat: *Young Woman Powdering her Face*.
Vroubel: *The Demon*.

Birth of Harry Clarke, Egon Schiele and Jan Zrzavy.

1891

Death of Arthur Rimbaud and Georges Seurat.

Gauguin's first journey to Tahiti.

Khnopff: *I Lock My Door Upon Myself*.

First poster of Henri de Toulouse-Lautrec: *Moulin-Rouge*.

Wilde: *The Picture of Dorian Gray*.

1892

Loie Fuller danced in Paris.

First Rosicrucian Salon.

Scandal caused by Munch's exhibition in Berlin.

Crane: *The Horses of Neptune*.

Degouve de Nuncques: *The Pink House*.

Thorn Prikker: *The Bride*.

1893

Death of Ford Madox Brown.

Gauguin: *Manao Tupapau: The Spirit of the Dead Keeps Watch*.

Munch: *The Cry*.

Toorop: *The Three Bricks*.

Verhaeren: *Hallucinated Landscapes*.

1894

Beardsley: illustrations for *Le Morte d'Arthur*.

Mucha: *Gismonda*, first poster for Sarah Bernhardt.

Schwob: *The Book of Monelle*.

1895

Gauguin's second journey to Tahiti.

Aman-Jean: *Young girl with Peacock*.

1896

Death of John Everett Millais, William Morris and Paul Verlaine.
Jarry: *Ubu-Roi*.

Louÿs: *Aphrodite*.

Moreau: *Jupiter and Semele*.

Segantini: *Love at the Spring of Life*.

Birth of André Breton.

1897

Gauguin: *Whence Come We? What Are We? Whither Do We Go?*

Munch: *The Frieze of Life*.

Last Rosicrucian Salon.

1898

Death of Aubrey Beardsley, Edward Burne-Jones, Stéphane Mallarmé, Gustave Moreau, Puvis de Chavannes and Félicien Rops.

Schwabe: *The Virgin of the Lilies*.

1899

Death of Giovanni Segantini.

1900

Death of John Ruskin, Albert Samain and Oscar Wilde.

Flournoy: *From India to the Planet Mars*.

Freud: *The Science of Dreams*.

1901

Death of Arnold Böcklin.

Gauguin and Charles Morice: *Noa-Noa*.

Lorrain: *Mr de Phocas*.

1902

Death of Otto Eckmann.
Maeterlinck and Debussy: *Pelleas and Melisande*.

1903

Death of Paul Gauguin (in the Marquises Islands) and James Abbott Whistler.

Scandal caused by Klimt's ceiling decoration for the University of Vienna.

1904
Death of Emile Gallé, Henri Fantin-Latour, George Frederick Watts.

Saint-Pol-Roux: *From the Dove to the Blackbird by the Peacock.*

1905
Death of Marcel Schwob.

Holman Hunt: *The Lady of Shalott.*

Die Brücke founded in Dresden by Ernst-Ludwig Kirchner, Erich Heckel and Karl Schmidt-Rottluff.

1906
Death of Eugène Carrière, Ernst Josephson and Jean Lorrain.

Picasso: *Woman with Fan.*

1907
Death of Alfred Jarry, Joris-Karl Huysmans and Giuseppe Pelizza da Volpedo.

Dulac: illustrations for *The Thousand and One Nights.*

Rackham: illustrations for *Alice in Wonderland.*

Cros: *The Collar of Claws (Le Collier de griffes).*

Spilliaert: *Woman on the Dike.*

Vallotton: *Nude on a couch, blue blanket, red cushions, yellow book.*

1909
Death of Nerée tot Babberich, Ranson and Wojtkiewicz.

Kubin: *The Other Side.*

Marinetti: *Futurist Manifesto.*

The Russian Ballet at Châtelet.

Birth of Francis Bacon.

1910
Death of Holman Hunt, Moréas, Henri Rousseau and Vroubel.

De Chirico: first 'metaphysical' paintings.

1911
Wassily Kandinsky, Alfred Kubin, Franz Marc and Gabriele Münter founded *Der Blaue Reiter* in Munich.

Duchamp: *Draught on the Japanese Apple Tree.*

1912
Casorati: *The Young Ladies.*

Kandinsky: *Concerning the spiritual in art and particularly in painting.*

Martini: *Twilight Butterfly.*

1913
Apollinaire: *Alcohols.*

1914
Mallarmé: *A throw of the dice never abolishes the hazard.*

BIOGRAPHICAL NOTES
AND LIST OF PLATES

AMAN-JEAN Edmond
Chevry-Cossigny, 1859-1936, Paris.

A disciple of Puvis de Chavannes and Rossetti, friend of Seurat, admirer of Verlaine, Samain, Rodenbach and of Villiers de l'Isle-Adam, he was a delicate and enthusiastic painter of feminine beauty which he celebrated in graceful oils and luminous pastels.

1. THE GIRL WITH THE PEACOCK. 1895. Paris, Musée des Arts Décoratifs.

BEARDSLEY Aubrey Vincent
Brighton, 1872-1898, Menton.

His drawings are of an elegance without equal and the influence of William Morris and the pre-Raphaelites led to the most intricate and perverse linear curves which were employed to illustrate the medieval legends (Malory's *La Morte d' Arthur*, 1893-1894) or the refined aesthetic works of the end of the century (Oscar Wilde's *Salome*, 1893; Beardsley's own *Story of Venus and Tannhauser*, 1895) in which his cynical and icy eroticism is amazing.

2. ISOLDE. Circa 1890. Gouache.

3. Illustration for Oscar Wilde's SALOME.

BERNARD Emile
Lille, 1868-1941, Paris.

'The Bretoniser', (Alfred Jarry). Along with Louis Anquetin around 1887 he laid the foundations of the 'cloisonnisme' theory which, after a meeting with Gauguin at Pont-Aven in 1888, gave way to the more fertile doctrine of 'synthetic' Symbolism. Félix

Beardsley. 1892-1893
Victoria and Albert Museum, London.

Fénéon wrote of Bernard's work: 'The wide outlines with which Mr Bernard delineates landscape and figure are the lead traceries of stained glass. The layout is simple and the figures would be reminiscent of traditional poses but for the odd outlandish gestures which are meant to disturb'. But whilst acknowledging that Gauguin seemed more successful in his attempts at Symbolism, it seemed to Emile Bernard that others had adopted his own ideas.

4. SAILING BOATS ON THE AVEN. 1889. Lithograph.

BÖCKLIN Arnold
Basle, 1827-1901, San Domenico di Fiesole.

One of the 'great lights' of Symbolism, his work only achieved its full dimension around 1870. A most gifted artist he could endow the lesser creatures of Graeco-Latin myth with an astonishing presence which sometimes bordered on caricature. From his brush centaurs, satyrs, unicorns, sirens, naiads and tritons acquired a vitality emanating from nature whose force is always evident in the painter's work. Böcklin reached lyric heights in landscape and he was able to make us aware of the perpetual battle between the vanity of human concerns and the impassibility of nature. 'One is amazed by this unity in dream, by this blindness in the fantastic, by this total naturalness in the supernatural' wrote Jules Laforgue of Böcklin in 1886. Referring to the painting, *Centaur and Blacksmith*, Giorgio di Chirico remarked in 1920 that 'he made one think that centaurs really existed in another time and that even today when crossing a street or when wandering around one could come face to face with a survival of that species'.

5. WAR. 1896. Dresden Staatliche Kunstsammlungen.

6. THE ISLAND OF THE DEAD. 1880. Leipzig, Museum der bildenden Künste.

BOLDINI Giovanni
Ferrare, 1842-1931, Paris.

A society painter of great virtuosity to whom we owe vivacious portraits of the personalities of the Belle Epoque. One of the most remarkable is that of Robert de Montesquiou, an outstanding dandy of the Symbolist period, who also inspired the Huysmans of *A Rebours* and the Proust of *A la recherche du temps perdu*.

7. PORTRAIT OF COUNT ROBERT DE MONTESQUIOU. 1891. Paris, Musée National d'Art Moderne.

BURNE-JONES Edward
Birmingham, 1833-1898, London.

It was his meeting with William Morris and later with Dante Gabriel Rossetti which influenced him against pursuing his studies in theology in order to devote himself entirely to painting. As Burne-Jones would become one of the greatest of the Symbolist painters, and the one most endowed with grace, this was a fortunate decision. His exquisite touch owed much to the Quattrocento, and in particular to Botticelli, but he also made a point of strict and orderly layout which served to illustrate enchanting legends and poetic myths and proved at the same time that exclusively narrative painting (all his subjects were borrowed from literature) could attain the heights of plastic beauty. *The Baleful Head* belongs to a series of ten vast panels illustrating the myth of Perseus which the artist carried out on commission in 1875.

8. THE BALEFUL HEAD. 1885-1887. Southampton, Southampton Art Gallery.

CARRIERE Eugène
Gournay, 1849-1906, Paris.

'Smoking in the children's room again!' said Degas ironically when looking at one of Carrière's many *Motherhoods*, while Félix Fénéon described it as follows:'The darkness is brightened by a hint of rose or pale yellow'. But Carrière belonged to Symbolism more because of the attention he paid to analogous relations, which led him to deliver a lecture in 1901 entitled, *Man, visionary of reality*, and because of such statements as 'The eye depends on the spirit', than on account of his portrayal of family sentiments in poorly ventilated interiors.

9. MOTHERHOOD. Rheims, Musée des Beaux-Arts.

CRANE Walter
Liverpool, 1845-1915, London.

By being able to establish a link between the socialist preoccupations of William Morris, the spiritual aspirations of the Pre-Raphaelites and the Symbolists' search for formal innovation, Walter Crane played a decisive role in the stylistic evolution of the 19th Century, in particular thanks to his inventive work as an illustrator, in the final analysis more useful and better inspired than his work as a painter.

10. ILLUSTRATION FOR 'A FLORAL FANTASY IN AN OLD ENGLISH GARDEN'. 1899.

DEGOUVE DE NUNCQUES William
Monthermé, 1867-1935, Stavelot.

Luc and Paul Haesaerts wrote in 1938: 'While the Impressionists see an image as lit from the exterior Degouve sees it as lit from within'.

At the beginning of his career Degouve was influenced by Jan Toorop and Henry De Groux but he was able to free himself from the overly mannered and superficial styles of the two artists. His work is really that of a visionary and the light which suffuses it is that of ecstasy ready to transform the slightest landscape into a sign of destiny.

11 THE BLIND HOUSE or THE PINK HOUSE. 1892. Otterlo, Rijksmuseum Kröller-Müller.

12. THE BLACK SWAN. 1896. Otterlo, Rijksmuseum Kröller-Müller.

Crane. *Cartoons for the Cause.* 1866

Jarry. L'Almanach illustré du Père Ubu. 1901.
Brussels, Bibliothèque Royale.

DENIS Maurice
Granville, 1870-1943, Paris.

'What a silly idea of Maurice Denis! He paints
nude women and children in nature, some-
thing which is never seen today and when
looking at one of his paintings it seems as if
the children are responsible for themselves
and that their shoe repairs cost nothing. How
far we are from railroad accidents: Maurice
Denis should paint in heaven because he is
ignorant of evening dress and Spam' (Arthur
Cravan, 1914). The formula of 'synthetic'
Symbolism gradually fades from Denis' work
but looses none of its elegance, and the nudes
in their blue-mauve tones are of an identical
chastity to the hordes of nuns and other holy
women who little by little invade their
territory.

13. THE ENGAGEMENT PROCESSION. 1894. Paris,
private collection.

14. THE SACRED WOOD. 1893. Paris, Musée
National d'Art Moderne.

ENSOR James
Ostend, 1860-1949, Ostend.

The most important part of Ensor's work was
carried out between 1888 and 1892 when
Symbolism was at its height. Its vein of
humour and of aggression was permanently
integrated into the movement (think of
Ubu-Roi by Alfred Jarry and the importance
given to the masks in that work) and this
feeling, in the case of the painter of *The Entry
of Christ into Brussels*, forms part of the darker
face of Symbolism and is close to the world of
Odilon Redon and of Alfred Kubin where
dream borders on nightmare. What was later
called Expressionism can be considered as
the development of the more stringent, as
well as the lighter sides of Symbolism, as
when the effort of grinding one's teeth
finally forces one to laugh.

15. DEATH PURSUING THE PEOPLE. 1896. Brussels,
Royal Library.

16. SELF-PORTRAIT SURROUNDED BY MASKS. 1899.
Private collection.

17. THE ENTRY OF CHRIST INTO BRUSSELS. 1888.
Detail . London, Louis Franck collection.

FILIGER Charles
Thann, 1863-1928, Brest.

In his unique art criticism devoted to Filiger
Alfred Jarry wrote in 1894, 'it is God's work
which remains static, a soul without animal
movement, canvas or board on which the
artist pins and collects the arrested flight of
one facet of the revolving beam'.
 Filiger was one of the most interesting
followers of Gauguin and in his 'chromatic
notations' he seems to have followed the
formula of 'synthetic' Symbolism to an

almost abstract conclusion. Also it seems that 'mystical messages' should be read into the crystalline composition of his sketches.

18. CHROMATIC NOTATION. Watercolour. Private collection.

GAUGUIN Paul
Paris, 1848-1903, Atouana.

With Gauguin, Symbolist painting reached both its highest summit and its most advanced point of formal invention. Previously Arnold Böcklin, Gustave Moreau, Puvis de Chavannes and Edward Burne-Jones had demonstrated in admirably different ways the repercussions Symbolism had on painting but they had not proposed as revolutionary a formula as that of 'synthetic' Symbolism, whose meaning transformed the major as well as the minor arts at the end of the 19th and the beginning of the 20th century. What in the hands of Emile Bernard was a simple stylistic procedure became for Gauguin a means of breaking finally with the perspective of space as inherited from the Renaissance and formed an ideal vehicle for Symbolist thinking. The resulting absence of pictorial depth and arbitrary colour encouraged the expression of myth, of dream and of the unconscious. The immediate consequence was the worldwide proliferation of Art Nouveau or Modern Art but the real long-term consequence was the birth of lyric or musical Abstraction around 1911. Gauguin's Polynesian adventures are too well known to insist upon and in any case his understanding of 'synthetic' Symbolism would develop into a search for 'real life' particularly on the amorous plane which would be a painful but exhilarating conquest.

19. THE VISION AFTER THE SERMON or JACOB WRESTLING WITH THE ANGEL. 1888. Edinburgh, National Gallery of Scotland.

20. REVERIE. 1891. Kansas City, Rockhill Nelson Gallery.

21. FATA TE MITI. 1892. Washington, National Gallery of Art (Chester Dale Collection).

22. MANAO TUPAPAU: THE SPIRIT OF THE DEAD KEEPS WATCH. 1893. New York, A. Conger Goodyear Collection.

23. HORSEMEN ON THE BEACH. 1902. Essen, Folkwang Museum.

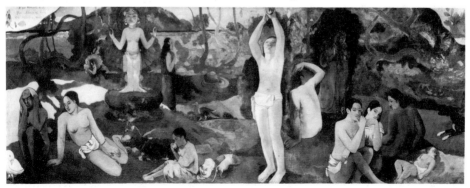

Gauguin. Whence Come We? What Are We? Whither Do We Go? Museum of Fine Arts, Boston.

GRASSET Eugène
Lausanne, 1841-1917, Sceaux.

A pupil of Viollet-le-Duc, he devoted himself principally to the graphic arts. A close study of the Japanese Ukiyo-e prints resulted in his frequent use of the arabesque as can be seen in his illustrations for *Story of the Four Aymon Sons, most noble and valiant knights* (1883), and from study of the techniques of stained glass he came close to the 'cloisonnisme' of Bernard. His greatest claim to fame however was his drawing for the Larousse dictionary of a woman blowing away the fluff of a dandelion.

24. SPRING. 1884. Stained glass. Paris, Musée des Arts Décoratifs.

HEINE Thomas Theodor
Leipzig, 1867-1948, Stockholm.

Very active in Munich Jugendstil circles, he was the most brilliant representative of the tendency towards irreverence and humour, which however landed him in prison, in 1898, for a political offence. In 1896 he became the editor and co-founder of the famous satirical review, *Simplicissimus*, for which he worked until the advent of Naziism in 1933. Many followers of Symbolism were inspired by the American dancer, Loie Fuller. Her 'serpentine dance' with its use of veils and coloured projections enthralled the Europe of the Belle Epoque.

25. LOIE FULLER. 1900. Illustration for the review 'Die Insel'.

HODLER Ferdinand
Bern, 1853-1918, Geneva.

It is difficult to believe that this robust engineer of huge compositions, based on extremely efficient rhythmic repetition, would have taken part in the First Rosicrucian Salon. Indeed Hodler was so profoundly in tune with the Symbolists that even when he abandoned his almost allegorical monumental works such as *Night* (1890), which is his most accomplished and impressive example of that genre, to concentrate on Swiss lake and mountain landscape, the intense spirituality of his work was not at all diminished but on the contrary became implicitly, and no longer only explicitly, significant. The fame he achieved during the early years of the 20th century did nothing to weaken the genius of the great Symbolist painter and the artists of the Expressionist 'Die Brücke' movement considered him as much their master as Edvard Munch.

26. NIGHT. 1890. Bern, Kunstmuseum.

HOLMAN HUNT William
London, 1827-1910, London.

Holman Hunt, along with Dante Gabriel Rossetti and John Everett Millais, was one of the founders of the pre-Raphaelite Fraternity in 1848. He explored in depth a paradoxical sense of reality whose quasi-photographic detail was made to serve an almost fanatical religiosity which at times bordered on bigotry. With this research in view he made four trips to Palestine and the Middle East in order to be able to depict more faithfully scenes he was to paint from the Old and New Testaments. After Tennyson's poem, *The Lady of Shalott*, he shows the chastisement of a young lady. She has been distracted by the

passage of a handsome knight from her divine task of weaving events she sees recorded in a mirror before her and she is punished by the sudden unravelling of her tapestry.

28. THE LADY OF SHALOTT. 1886-1905. Manchester, City Art Galleries.

KELLER Ferdinand
Karlsruhe, 1842-1922, Baden-Baden.

Keller was a historical painter nicknamed the 'Badois Makart' after the example of the Austrian, Hans Makart (1840-1884), who had been so successful in this domain. In the latter part of the 19th century he came under the influence of Arnold Böcklin and the effect of this influence is to be seen in mythological landscapes of some charm and force. Keller's *Tomb of Böcklin* was inspired by the awe he felt for the Basle Master but can also be interpreted as his rendering of Böcklin's famous, *Island of the Dead*.

29. THE TOMB OF BÖCKLIN. 1901-1902. Karlsruhe, Staatliche Kunsthalle.

KHNOPFF Fernand
Grembergen-lez-Termonde, 1858-1921, Brussels.

'With other equally admirable people you have provided the argument of my thesis on this need for an ideal which is already called the First Rosicrucian Salon. The reason why your works were not displayed in a place of honour is that my assistant, in whom I placed all my confidence, had covered walls destined only for beauty with the most ghastly pictorial madness. I believe you the equal of Gustave Moreau, of Burne-Jones, of Chavannes and Rops and you are a master. *Silence, The Sphinge* and *Knight and Chimera* are

masterpieces and this catalogue needs only your name. I pray the Angels, friend to my grand design, that you be faithful to the Rosicrucian Order which through my voice proclaims you to be an immortal and admirable master!' In such terms Joséphin Pédalan addressed Khnopff in 1893 in the catalogue of the Second Rosicrucian Salon. Such homage surprises today only in the measure by which we are tempted to imagine the Rosicrucian Salons as idealistic, end of the century, bazaars and we see Pédalan under the guise of a charlatan reacting solely to symbolist extravagance. The fame achieved by the master of silence whose major work is surely, *I Lock my Door upon Myself*, would be a proof to the contrary and for a whole generation of artists and poets the idolatrous portrait of the artist's sister, *Marguerite Khnopff*, possessed the value of a revelation.

30. SILENCE. 1890. Pastel. Brussels, Royal Belgian Museums of Fine-Arts.

31. THE DESERTED CITY. 1904. Brussels. Drawing. Royal Belgian Museums of Fine-Arts.

32. PORTRAIT OF THE ARTIST'S SISTER. 1887. Brussels, B. Thibaut de Maisières Collection.

33. I LOCK MY DOOR UPON MYSELF. 1891. Munich, Neue Pinakothek.

KLIMT Gustav
Vienna, 1862-1918, Vienna.

Klimt was the great Viennese Symbolist painter and constituted an involuntary link between the movement and Freud's psycho-analytical research. The turning point in Klimt's career occurred in May 1900 just a few months after the publication of *The Science of Dreams*. Klimt, hitherto a society painter, was commissioned by the University of Vienna to

paint a work which he entitled *Philosophy*. It shocked both citizens and colleagues and the latter signed a petition in which they qualified the composition as 'intolerable'. Klimt drew his inspiration from painted Greek vases, the Ravenna mosaics, the work of his contemporaries Makart, Franz von Stuck, Khnopff and Toorop and yet he was wholly original particularly in his rendering of the female figure which was such a popular theme of the era. According to Alexandra Comini, in these portraits of women, Klimt reaches 'the best illustration of the theme central to Art Nouveau which is that of decoration as from within' because 'without that extraordinary superabundance found in the work of Klimt carrying a double function between ornament and symbol it is possible that a younger generation of painters would not have discovered such rich effects in the attainment of the psyche'. These portraits, and also the landscapes of Klimt, show in different ways the same rejection of pictorial depth as is evident with Gauguin's work and indeed either of these artists could be said to be the only ones of the Symbolist period to have confused the act of painting with the immediacy of sensual passion.

34. FRITZA RIEDLER. 1906. Vienna, Oesterreichische Galerie.

35. THE KISS. 1907-1908. Vienna, Oesterreichische Galerie.

36. THE SEA. Circa 1898. Hamburg, private collection.

37. EXPECTATION. Circa 1905-1909. Vienna, Osterreichisches Museum für Angewandte Kunst.

KLINGER Max
Leipzig, 1857-1920, Grossjena bei Naumburg.

With his series of prints made in 1881, *Paraphrase on the Discovery of a Glove*, in which fantasy plays a major role, Max Klinger attained an important position in the evolution of Symbolist thought. He constitutes,

Klinger. Paraphrase on the Discovery of a Glove. The Rest. 1880. Private Collection.

as it were, a bridge between Arnold Böcklin and Giorgio di Chirico, but his contribution really went further than that and in his painting, *The Blue Hour* (1890), he can be seen as a painter of ecstasy while in his ambitious *Christ in Olympus*, (1897) he seems to indicate a mystic reconciliation between christian and pagan aspirations. His monumental chryselephantine statue of Beethoven which was in the heroic vein of Symbolism, was presented to the Viennese Secessionists in 1902 along with a series of seven panels by Klimt dedicated to the composer's ninth Symphony.

38. PARAPHRASE ON THE DISCOVERY OF A GLOVE. FEAR. 1881. Print. Private collection.

KOBLIHA Frantisek
Prague, 1877-1962, Prague.

Along with Jan Konupek (1883-1950), Jan Preisler (1872-1918), Josef Váchal and the sculptor Frantisek Bilek, this inspired illustrator of Nerval, Poe, Wilde, Huysmans and Maeterlinck contributed some of the most original work of Czech Symbolism mainly in the domain of graphics. His disturbing representation of seductive women was close to Moreau's *Salome* and the sometimes fantastic atmosphere notable in his work brings him close to Kubin.

39. Lithograph.

KUBIN Alfred
Leitmeritz, 1877-1959, Wernstein am Inn.

Kandinsky wrote of Kubin, his colleague in the Blaue Reiter, in 1912, in the article *On the spiritual in art and particularly in painting* that 'he is in the forefront among those lucid beings' who 'reflect the great darkness which is to come'. Kandinsky added: 'An irresistible force hurls us into the horrible atmosphere of Nothingness. This force is apparent in the drawings of Kubin as it is to be seen in his novel, *The Other Side*'. This book was published in 1909 and is one of the masterpieces of fantastic literature. In it, and in his graphic and pictorial work, Kubin explores the relationship between Symbolism and dreams, with an energy which brought him to the borders of nightmare.

40. BEARERS OF A PARCEL. Drawing. Private collection.

LEVY-DHURMER Lucien
Algiers, 1865-1953, Le Vesinet.

The work of Levy-Dhurmer, although that of a minor artist, is interesting in that he illustrated the three principal tenets of Symbolism in a thoroughly convincing manner: *manifest* Symbolism in such works as *Eve*; *latent* Symbolism in portraits like that of the actress Marguerite Moreno, the muse of Marcel Schwob, and real or imaginary landscapes such as *My Mother, One Evening, Saw the City of Ys*.

41. EVE. 1896. Pastel. Paris, Michel Perinet Collection.
42. MY MOTHER, ONE EVENING, SAW THE CITY OF YS. 1897. Pastel, Brest, Museum of Fine-Arts.

43. PORTRAIT OF MARGUERITE MORENO. Pastel. Paris, private collection.

MAILLOL Aristide
Banyuls-sur-Mer, 1861-1944, Perpignan.

Before devoting himself exclusively to sculpture where for forty years he fashioned the same malleable nudity of plump, young

peasantry Aristide Maillol painted some of the freshest of Nabis compositions such as the portrait of a young woman bathed in golden light which is an evocation of desire rather than an atmospheric aura.

44. WAVE. Circa 1900. Woodcut.

45. PROFILE OF A YOUNG GIRL. Perpignan, Hyacinthe Rigaud Museum.

MARÉES Hans von
Elberfeld, 1837-1887, Rome.

In the work of Arnold Böcklin the meeting between man and nature often assumes the form of conflict as humanity refuses to allow its own instincts to express themselves. With von Marées however this meeting assumes an idyllic allure probably springing from some reflection on Graeco-Latin antiquity. Puvis de Chavannes could be reproached for a similar attitude but he evinces less sensuality than the painter of *The Garden of the Hesperides.*

46. DIANA BATHING. 1863. Munich, Bayerische Staatsgemäldesammlungen.

MILLAIS John Everett
Southampton, 1828-1896, London.

He was one of the three founders of the pre-Raphaelite Fraternity along with William Holman Hunt and Dante Gabriel Rossetti and was also the most popular painter of the three. His *Ophelia* of 1852 received widespread acclaim and when Sir Hubert von Herkomer painted Queen Victoria in 1901 on her deathbed he was not able to resist making a new version of Millais' work. It could be that Millais' *Ophelia* deserves a better reputation in so far as the madness of Hamlet's unhappy

fiancée links her to the beauties of nature and guarantees what seems to be the most peaceful of deaths. It should not be forgotten that the link between nature and culture remained one of the principal objectives of the entire Symbolist movement.

47. OPHELIA. 1852. London, Tate Gallery.

MOREAU Gustave
Paris, 1826-1898, Paris.

In 1864 the confrontation of *Oedipus and the Sphinx* marked the real beginning of Gustave Moreau's career and from then until his death he pursued with unshakeable fervour the exploration of the essence of legendary figures on whom he conferred psychological and lyrical overtones. The most important element of his work concerns his confrontation with the Eternal Woman and from *Salome* to *Helen of Troy*, from *Leda* to *Pasiphäe* time and time again the Seductress and the Animal Woman occupy the stage, crystallizing in grottoes of precious stones the space of the myth and that of the painting. Man, face to face with the menace of castration, is more often in the position of Orpheus who is torn asunder by the Furies than that of Oedipus overcoming the Sphynge or Hercules forced in one night to deflower the fifty daughters of his host, Thespius. Moreau himself seemed to remain poised between fascination and terror. It was after some reflection on the idea of sacred marriage (hieros gamos) dear to those heretics of the early Christian era, the Gnostics, that the painter in his later years became reconciled to a more harmonious conception of heterosexual relations. This sacred form of union in which the male and female principles exult in reciprocal joy until they fuse into one unity is celebrated in his *Jupiter and Semele* of 1896. Moreau considered this important

work as his spiritual legacy. Later on he was to inspire André Breton, and his work had a direct influence on the conception of Breton's *L'Amour Fou.*

48. THE 'TATOOED SALOME'. 1876. Detail, Paris, Gustave Moreau Museum.

49. THE SCOTTISH RIDER. Detail. Paris, Gustave Moreau Museum.

50. PASIPHÄE. Watercolour. Paris, Gustave Moreau Museum.

51. THE FAIRY WITH THE GRIFFIN. Watercolour. Paris, Gustave Moreau Museum.

52. THE RAPE OF EUROPA. Watercolour. Paris, Gustave Moreau Museum.

53 DELILAH. Watercolour. Paris, Gustave Moreau Museum.

54. LEDA. Watercolour. Detail. Paris, Gustave Moreau Museum.

MORRIS William
Walthamstow, 1834-1896, Kelmscott Manor.

Nobody did more for the decorative arts of the 19th century than William Morris. This painter, poet, designer and militant socialist was convinced of a possible reconciliation between Art and Labour, between the People and Beauty. He adopted with enthusiasm John Ruskin's ideas as to the much needed harmony between the different sectors of artistic activity, and he played a predominant role in the definition of the international style which would be known as Art Nouveau. He was actively seconded in this by Charles Robert Ashbee, Walter Crane, Arthur Heygate Mackmurdo and Charles Annesley Voysey. The decisive role played by Morris in the reawakening of the graphic arts deserves more attention than his influence on the aesthetics of the house interior (furniture, stained glass, wallpaper). He introduced a new typeface of fine quality, the Golden Type (1890), and he gave a most elegant style to the books published by The Kelmscott Press from 1891 onwards, characterised by flowered margins and enhanced by traceries after the manner of illuminated manuscripts of the

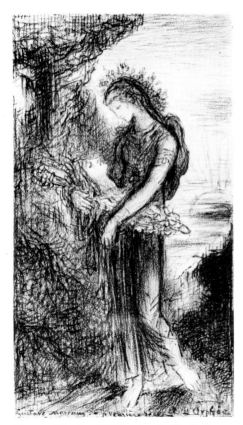

Moreau. Thracian Girl Carrying the Head of Orpheus. Musée Gustave Moreau, Paris.

Middle Ages. These flourishes were in harmony with the typesetting and also with the wood engravings of Morris' friends particularly those of Burne-Jones.

55. THE WELL AT THE WORLD'S END. 1896. Margin by William Morris, illustration by Edward Burne-Jones.

MUCHA Alphons
Ivancice, 1860-1939, Prague.

The turning point of Mucha's career came in 1894 when Sarah Bernhardt asked him to

Morris. Wall-paper with floral design.

make a poster for *Gismonda* in which she played the leading role. From that moment Mucha was a success and his manner of working, one of the most stylised of the Art Nouveau movement, instantly recognisable. The Moravian artist was requested to make further posters for the famous actress and also to design stained glass, jewels, gowns and various decorative works. His special way of depicting women's hair particularly in the 'blonde' version of the poster for Job cigarette

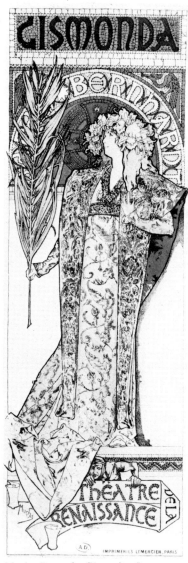

Mucha. Poster for *Gismonda*. 1894

papers gave rise to the appellation of 'Noodle Style'. However Mucha was not only a brilliant graphic artist but also a true Symbolist painter. He shared the characteristic preoccupations of the Symbolists and he was interested in spiritual phenomena. On returning to his country in 1911 he undertook a series of paintings honouring the Slavic people.

56. POSTER FOR JOB CIGARETTE PAPERS. 1898.

MUNCH Edvard
Loeiten, 1863-1944, Ekely.

'I was walking down the road with two friends — the sun was setting and the sky became crimson like blood — I felt the approach of melancholy. I stopped and leaned against a fence feeling deadly fatigued; above the blue-black fjord and the town floated clouds of blood and tongues of fire; my friends continued on their walk but I stayed, trembling with anguish. I thought I had heard the terrible and infinite cry of nature'. In these terms Munch retraced the origins of his famous painting, *The Cry* (1893) which is generally presumed to be the beginning of Expressionism. The tragic intensity which characterises the work of Munch does not prevent this painting deriving directly from Symbolism and constituting a sort of powerful variant on Gauguin's 'synthetism'. Indeed the nature-culture relationship in Munch's work is nearer that confrontation of Böcklin than the harmony Gauguin tried to find in Britanny and Polynesia. In the same vein the Norwegian painter's use of colour tends to emphasise the subjects' psychological torments rather than to signify the unconscious dimension, or the narrative, as is evident in Gauguin. In the work of both artists however the arabesque and the use of strong colour play a major function in establishing a direct relationship between the individual and the cosmos, and lend a spiritual and real significance to the surface of the work. The attitude of fear and fascination which is Munch's towards love and women, if it is radically foreign to the painter of Tahitian women, does however make one think irresistibly of Gustave Moreau. In *Puberty*, (1894), a young girl's similar terror and perhaps an equally similar wish to be loved is portrayed and again in his numerous versions of *The Kiss* surely the outcome is the question of the fusion of a man and woman in one entity when, as a consequence, the individual is transcended by the glorification of love.

57. MADONNA. 1894-1895. Oslo, Nasjonalgalleriet.

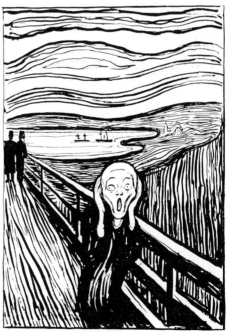

Munch. The Cry. 1893

58. PUBERTY. 1894. Oslo, Nasjonalgalleriet.

59. THE NEXT DAY. 1894-1895. Oslo, Nasjonal-galleriet.

60. WOMEN ON THE RIVERBANK. 1898. Woodcut.

61. THE KISS. 1898. Detail. Woodcut.

PUVIS DE CHAVANNES Pierre
Lyons, 1824-1898, Paris.

Puvis de Chavannes is closer to allegory than to symbol and for this reason his work usually attracts discussion rather than appealing to the emotions. His pictorial dissertation is of high quality and is written in readable form. He delivered a composition with a strong message and this helped to prepare public opinion for the advent of Symbolism and encouraged artists themselves in matters of style and simplification. The Pantheon frescoes, dedicated to St. Genevieve, may seem extremely cold and remote to us but we must not forget that *The Poor Fisherman* had a strong influence on many young artists and that Gauguin pinned a reproduction of *Hope* onto the wall of his Tahitian hut.

62. ST. GENEVIEVE WATCHING OVER THE SLEEPING CITY. Paris, Pantheon.

63. YOUNG GIRLS AT THE SEASIDE. 1879. Paris, Louvre Museum.

64. YOUNG GIRLS AT THE SEASIDE. 1879. Paris, Louvre Museum.

65. THE POOR FISHERMAN. 1881. Paris, Louvre Museum.

66. HOPE. Circa 1871. Paris, Louvre Museum.

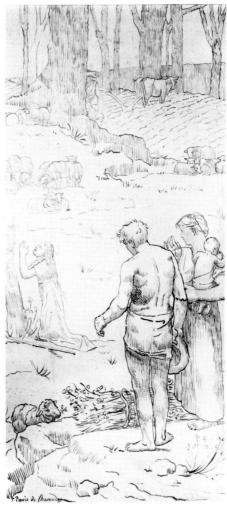

Puvis de Chavannes. Life of Saint Genevieve. Manoukian Collection, Paris.

REDON Odilon
Bordeaux, 1840-1916, Paris.

In 1881 Huysmans wrote about Redon's early works — 'the realm of nightmare invades art'. He continued: 'Add frightening, somnambulist figures akin to those of Gustave Moreau to macabre surroundings and maybe you will have an idea of the bizarre talent of this young painter'. Redon was also the clearest exponent of the Symbolists' criticism of Impressionism and he remarked to Sérusier: 'I refused to embark on the Impressionist boat as there was not enough headroom'. He further added that 'in the palace of truth' the Impressionists could only see 'the chimney' and that 'they ignore all that transcends, illuminates or amplifies the subject in the region of mystery, in the trembling of the irresolute and its enticing disquiet. They are frightened and wary of what the unexpected, the undefined and the unexplained means to our work and gives it its enigmatic character. They are veritable parasites in devoting themselves to a purely visual art and have closed it off to even the smallest attempt, even in the dark areas, which would allow it to transcend itself and be suffused with the light of spirituality. Here I refer to a light which comes from within and which escapes analysis'. Redon looked for this light in unexpected oppositions of colour which preceded and heralded certain researches into matters which the Surrealists Max Ernst and Oscar Dominguez would explore more systematically. However 'The Mystery Man', as he was called by Alfred Jarry, was sometimes betrayed by his own graphic weakness, a failing rare among the Symbolists. His charcoal drawings and lithographs are outstanding in their strangeness and their authenticity of experience and the lithographs in particular are closer to the world of nightmare than that of dream.

67. HELMET. Circa 1885. New York, Metropolitan Museum.

68. PORTRAIT OF MISS VIOLETE HEYMANN. 1910. Pastel. Cleveland, Museum of Art.

69. THE BIRTH OF VENUS. Pastel. Paris, Petit Palais Museum.

70. PEGASUS TRIUMPHANT. Circa 1905-1907. Otterlo, Rijksmuseum Kröller-Müller.

71. CLOSED EYES. 1890. Paris, Louvre Museum.

ROPS Felicien
Namur, 1833-1898, Essonnes.

Rops could well write about Baudelaire: 'We met in the grip of a strange love — the love of the original crystallographic form and a passion for the skeleton'. This meeting of minds is not obvious today nor is the 'perversity' and 'Satanism' with which the illustrator of Barbey d'Aurevilly's *Diaboliques*, or Pédalans's *Vice Supreme*, was credited by several of his well-known contemporaries. His works appear to be merely rhetorical where all is explained but nothing is felt.

72. PORNOCRATES. Print.

ROSSETTI Dante Gabriel
London, 1828-1882, Birchington-on-Sea.

'Rossetti was not an authentic Englishman but a great Italian suffering in the hell of London' so Ruskin wrote about this son of an Italian political refugee who founded the pre-Raphaelite Fraternity in 1848 along with William Holman Hunt and John Everett Millais. Teodor de Wyzewa also thought, 'his heredity predominated over the influences of

education and background. This explains why, at the same time, he can be superstitious but an atheist, intelligent but prodigious, complicated but naif, incapable of reflection but passionately sensitive to beauty'. The sensuality, the softness and absence of rigour in his work is in evident contrast to the dryness of Holman Hunt and the melodramatic feeling of Millais. From 1860 onwards he was acknowledged as the leader of a group of artists and poets, including Whistler and Swinburne, who insisted on the importance of freeing art from moralistic implications. His best-known work is probably *Beata Beatrix* (1863) and in it, according to Esther Wood, he endeavoured to depict, 'not the real death of Dante's beloved but rather a mystical ecstasy in which her approaching death is revealed to her. She is sitting on a balcony above Florence, already in morning for its imminent loss, and before her is a sundial marking the fatal hour. A dove flies towards her bearing in its beak a poppy, the symbol of sleep. Beatrice's charming face is uplifted as if to greet the invisible messenger and is suffused with a perfect tranquillity. She appears to have received the supreme benediction and to be filled with an infinitely sweet and profound contentment. However an earthly fatigue is visible on her forehead and on the pale, half-open lips'.

73. DANTE'S DREAM. 1856. Watercolour. London, Tate Gallery.

74. BEATA BEATRIX. 1863. London, Tate Gallery.

SCHWABE Carlos
Altona, 1866-1926, Avon.

Although of Swiss extraction Schwabe spent the greater part of his life in Paris and he is notable in the Symbolist movement for his unequalled works of mawkish religious alleg-ory and his overly meticulous, academic execution. His illustrations for *The Childrens' Gospel*, by Catulle Mendés, were a highpoint of the First Rosicrucian Salon in 1892 and he also produced the poster for this exhibition. Schwabe illustrated Zola's *Dream*, Baudelaire's *Les Fleurs du Mal* and Albert Samain's *The Infanta's Garden*. Thus his connections with the Symbolist movement were quite valid even though his work bordered on outrageous caricature particularly in such paintings as *The Virgin of the Lilies, The Death of the Gravedigger* and *Marriage of Poet and Muse*.

75. THE VIRGIN OF THE LILIES. 1898. Watercolour. Paris, Jean-Claude Brugnot Collection.

SEGANTINI Giovanni
Arco, 1858-1899, Schafberg.

Segantini described his painting, *Love at the Spring of Life*, (1896) as follows: 'It depicts the joyful and carefree love of woman and the pensive love of man as they embrace in the natural vigour of youth and springtime. The path they are treading is narrow and bordered by rhododendrons in flower. They are dressed in white (a pictorial reference to the lily). 'Eternal love', say the red rhododendrons, 'eternal hope' reply the evergreen privets. An angel, mystical but unquiet, spreads his great wing over the mysterious spring of life. Water springs from bare rocks, both a symbol of eternity. The scene is bathed in sunlight, the sky is blue. I indulge my eye in harmonies of white, green and red and I particularly want the greens to be noticed'. Symbolist inspiration and the use of neo-Impressionist techniques meet and result in work of extreme sensitivity on the part of the Italian painter and we can perceive the mark of a tender soul prematurely scarred by suffering and poverty. The powerful realism of his peasant and mountain scenes prior to 1891 were

Schwabe.
L'Evangile
de l'Enfance.
Le Sacré.

followed by work which can be called allegorical except that the figures, bearers of portents, are taken directly from most unhappy childhood memories. In 1911 Karl Abraham, a pupil and friend of Freud, wrote a thoughtful and kindly analysis on the work of Giovanni Segantini.

76. LOVE AT THE SPRING OF LIFE. (The Fountain of Youth). 1896. Milan, Civica Galleria d'Arte Moderna.

SEURAT Georges
Paris, 1859-1891, Paris.

It may seem surprising that Seurat's rigidly controlled aesthetic system could show more than just an affinity with Symbolism. Seurat thoroughly understood and made frequent use of the arabesque and a remarkable sensitivity is apparent in his admirable pencil drawings. He intended neo-Impressionist technique to be supple enough to render genre scenes as well as landscapes and we must also remember that the great Italian neo-Impressionist painters such as Guiseppe Pellizza da Volpedo, Gaetano Previati and Giovanni Segantini were also important Symbolist painters as is also true of the Belgian, Theo van Rysselberghe and the Dutch, Thorn Prikker and Toorop. In any case *Young Woman Powdering her Face* (Seurat's companion, Madeleine Knobloch, posed for the painting) is one of the most beautiful of Symbolist portraits and here he knows exactly how to harmonise with the *being* of the model and the setting in which she is placed according to the law of 'simultaneous contrast'. Initially the painter's face was to be seen in the little mirror instead of the later vase of flowers.

77. YOUNG WOMAN POWDERING HER FACE. 1889-1890. London, Courtauld Institute of Art.

SMITH Elise Muller, known as Hélène.

This famous Geneva medium was under observation by the psychologist Theodore Flournoy, who, in 1900, published the result of his reflections on her case under the title, *From India to the planet Mars.* He recounts how, under the influence of a 'spirit' called Leopold, she would divulge information about Mars and in her trance-like state speak 'a Martian language'. She accompanied this with 'documentary drawings' in the usual style of a medium which is naif and marked by rhythmic elements. Later on Hélène Smith painted vast religious works in a totally different spirit but pertaining to her spiritualist background. These works are reminiscent of the pre-Raphaelite compositions or of works exhibited at the Rosicrucian Salons.

78. HÉLÈNE SMITH AND HER GUARDIAN ANGEL. 1922. Paris, private collection.

SPILLIAERT Leon
Ostend, 1881-1946, Brussels.

Like Edvard Munch, Spilliaert was the victim of persistent anxiety which was probably the reason why he remained resolutely independent with regard to the various groups of artists and intellectuals. In his case, more clearly than that of Ensor, it is noticeable how a certain dramatisation of the Symbolist vision led naturally to Expressionism, as happened with Munch. His close friendship with Emile Vaerhaeren however leaves no doubt about his adherence to Symbolism. Watercolour, pastel and coloured crayons afforded him a more flexible medium than oil painting and permitted the rendering of the slightest inflexion of a variable humour, and also helped the artist to record faithfully a particular face or seascape. His troubling,

and troubled, work recalls that of Giorgio di Chirico.

79. WOMAN ON THE DIKE. 1908. Brussels, Royal Belgian Museums.

THORN PRIKKER Johan
The Hague, 1868-1932, Cologne.

Thorn Prikker went through an Impressionist and neo-Impressionist period but his enthusiasm for the works of the Flemish Primitives and the example of Gauguin, Maurice Denis and in particular Jan Toorop led him to the practice of a flamboyant Symbolist manner in which the arabesque is imbued by a strong and exceptional mysticism. He professed a typically Symbolist approach when he declared that he was more interested in the translation of feeling than the mere description of outward appearances. In his best-known work, *The Bride* (1892), the organisation of the arabesque and its amazing dynamism have the prime function of establishing the mystical union which is taking place between the nun pronouncing her vows and the crucified Christ isolating them from common humanity. The cascading flowers and the flaming candles are there to underline the tensions of the feelings of 'the bride of Christ' and this erotic register does not astonish if we bear in mind the example of St. Theresa of Avila. One has to admire the poetic device which transforms the nun's crown of thorns. Later on, as was the case with Maurice Denis and Jan Toorop, Thorn Prikker changed in style and became a banal purveyor of religious images.

80. THE BRIDE. 1892. Otterlo, Rijksmuseum Kröller-Müller.

TOOROP Jan
Poerworedjo, 1858-1928, The Hague.

Jan Toorop was extremely susceptible to the various influences current in Europe in the last quarter of the 19th century and he seems to have neglected none from the pre-Raphaelites to the Impressionists, passing by Ensor, Khnopff, William Morris, Maeterlinck, Pédalan, Redon, Verhaeren and Whistler. This dispersion of enthusiasm and preoccupation did not prevent him from the practice of a highly original Symbolist painting in which the Art Nouveau arabesque has the task of translating the intensity of mystical feeling which, in his works, attains a frenzy of execution which is quite unique. 1893 was a particularly rich year for Toorop and he produced among others *Fatality*, *The Three Brides* and *Song of our Time*. His use of linear deformation has often been attributed to his Javanese upbringing which is not surprising as Javanese batiks were responsible for a renewed interest in the art of textiles, particularly in England, as is witnessed by the success of the Liberty prints (called the Liberty Style in Italy). Gauguin had never disguised his admiration for the art of southeast Asia and the East-Indies and he was a particular admirer of the frieze of the temple of Borobudur in Java.

81. DELFTSCHE SLAOLLE. Poster. 1895.

82. THE THREE BRIDES. 1893. Otterlo, Rijksmuseum Kröller-Müller.

VACHAL Josef
Milavec, 1884-1969, Studenany.

Vachal's most obvious connection with advanced Symbolist thinking is clearly seen in his tormented graphics, close in spirit to the work of the Dutch artists Thorn Prikker and Toorop. He also gives evidence of mystical and occult preoccupations. Vachal read the works of Blake, Jakob Bohme, Corneille Agrippa and St. Theresa of Avila and he took a definite interest in the widespread spiritualist movement of the late 19th century.

83. THE SMALL ELF'S PILGRIMAGE. 1911. Woodcut.

VALLOTTON Felix
Lausanne, 1865-1925, Paris.

In the milk-and-water world of the Nabis Vallotton had the effect of a tot of rum. He was the only one of the group to prevent *The Talisman* (which Gauguin had dictated to Paul Sérusier in 1888, at the Bois d'Amour) from falling into the plastic and spiritual weakness in which the 'synthetic' formula found itself. Vallotton's use of the dictum was different to that of Gauguin but until the end of his life he continued to employ a strong and vigourous modelling. He illuminated the placid scenes of bourgeois existence, so dear to Bonnard and Vuillard, with a ferocious intensity and he seemed prey to a violence which afforded him no rest and which in his portraiture was close to the domain of psychiatry. As a result he made excellent portraits and landscapes in the Symbolist vein but in the genre Symbolist scenes at which Sérusier and Maurice Denis excelled he could not resist a tendency to cariacature. He surpassed himself with what can be called the Symbolist Nude for example in *The Bather* also called *The Spring*, of 1897, or *Nude on a Couch, blue blanket, red cushions, yellow book* (1905) which is a masterpiece of discipline and obscenity. Vallotton's work is an example of what can be called latent Symbolism as opposed to manifest Symbolism.

84. NUDE ON A COUCH, BLUE BLANKET, RED CUSHIONS, YELLOW BOOK. 1908. Lausanne, Paul Vallotton Collection.

85. THE MURDER. 1893. Woodcut.

86. IDLENESS. 1896. Woodcut.

VROUBEL Michael Alexandrovich
Omsk, 1856-1910, St. Petersburg.

Michael Vroubel was directly influenced by the Romantics but he was, at the same time, the greatest Symbolist in Russian painting. He wished 'to elevate his spirit through the expression of grandiose images thus removing himself from the infamous daily hubbub'. He owed his Romantic leanings to Lermontov (1804-1841) and was greatly influenced by the latter's poem, *The Demon*. Lermontov's Demon is not really a diabolical creature but a frenzied image of a human being, torn by contradictory aspirations, such as Don Juan, Melmoth or Maldoror. As in *The Swan Princess* (1900), Vroubel tried to portray the various creatures of ancient legend by means of his unique technique which broke down figures and objects into lozenge-shaped facets. In several of his drawings he was able to relate the traditions of popular Slavic art and the springlike flowering of Art Nouveau.

87. THE DEMON. 1890. Moscow, Tretiakov Gallery.

WATTS George Frederick
London, 1817-1904, London.

Watts was a leading light of British Symbolist painting. His work, although in the pre-Raphaelite vein, was distinguished from the hyperrealism of Holman Hunt and Millais and from the dream-like atmosphere of Rossetti and the charming stylisation of Burne-Jones. Watts was at his best when depicting allegory, and allegory which was far removed from everyday life and even from history itself. The pre-Raphaelites however had evinced no hostility to historic events or everyday realities. 'I am painting Hope', he wrote, 'a woman seated on the globe, her eyes bound; she is playing a lyre on which all the strings are broken save one. She tries to create music by plucking this string and she listens intensely to the miserable sound'.

88. HOPE. 1885. London, Tate Gallery.

WHISTLER James Abbott McNeill
Lowell, 1834-1903, London.

Whistler's extreme refinement, which is such a characteristic of his work, probably prevented him from undertaking any aesthetic adventure without slight mental reserve. His exquisite taste spared him any vagaries of genius even when with reference to his *Nocturne in Black and Gold* he was accused by Ruskin 'of throwing a pot of paint at the public's head'. (1877). Many of the portraits Whistler executed in what he referred to as 'a harmony' or 'a symphony' were much less exercises in painterly style, as he professed to believe, than perfect examples of Symbolist portraiture in which the relation between the model, the composition and the colour finds its meaning in an expression which is as much aesthetic as psychological.

89. MISS CECILY ALEXANDER. 1872-1874. London, Tate Gallery.

ZUMBUSCH Ludwig von
Munich, 1861-1927, Munich.

Zumbusch's delightful cover for the review,
Jugend (Youth), which he made in 1897 is a
reminder that the specific Symbolist style at
the end of the century was also a style in
vogue with young artists which was witnessed
in Munich by the creation of Jugendstil while
in Madrid, in 1901, a certain Picasso made
his first appearance in the review, *Arte Joven*
(Young Art).

90. Frontispiece for "*Jugend*", 1897.

PHOTOGRAPHIC CREDITS

AMAN-JEAN

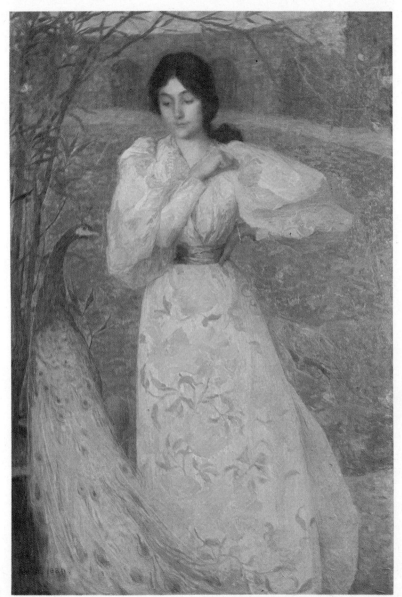

1

BEARDSLEY

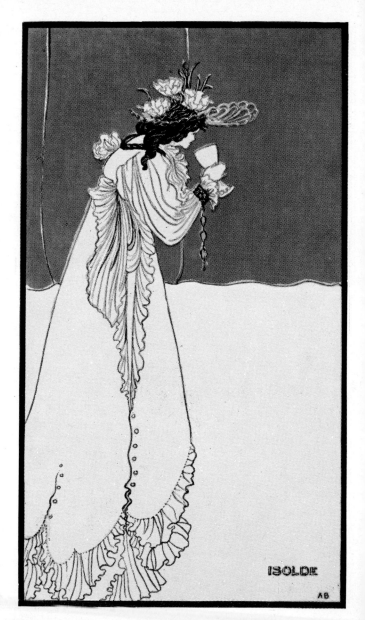

ISOLDE

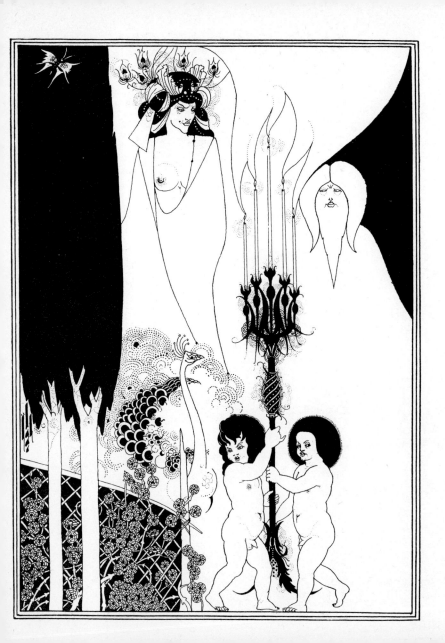

BERNARD

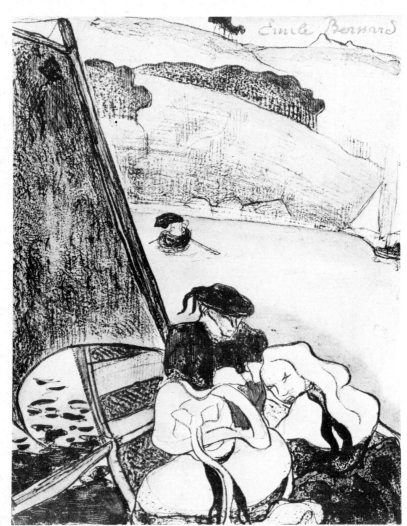

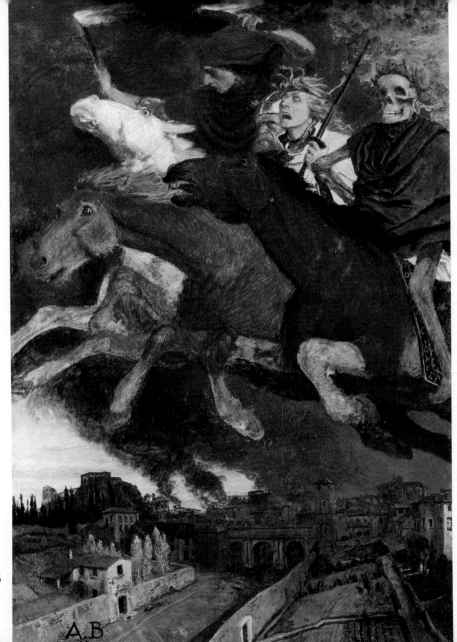

5

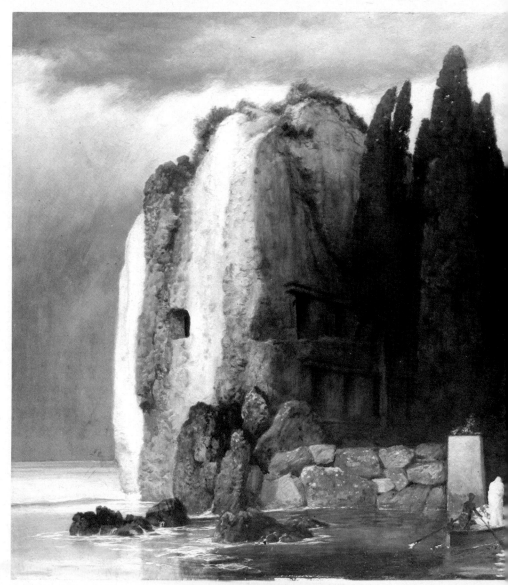

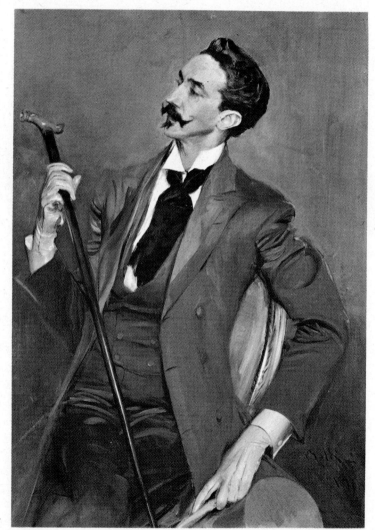

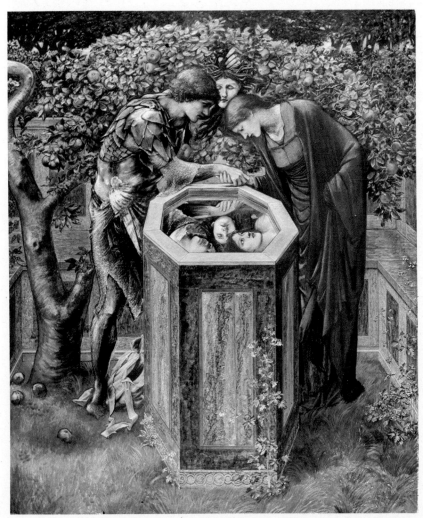

CRANE

When Lilies of the day are done,
And sunk the golden westering sun.

DEGOUVE DE NUNCQUES

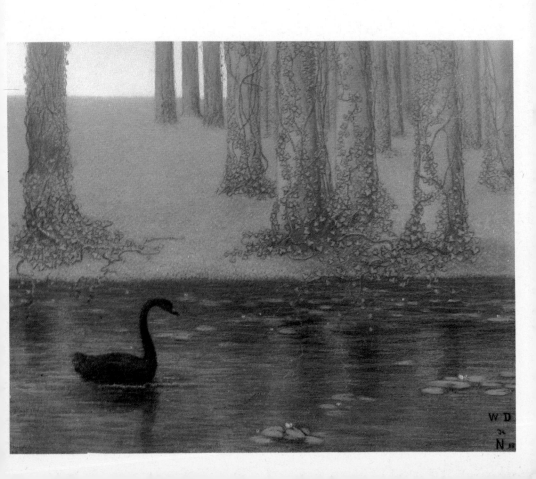

DENIS

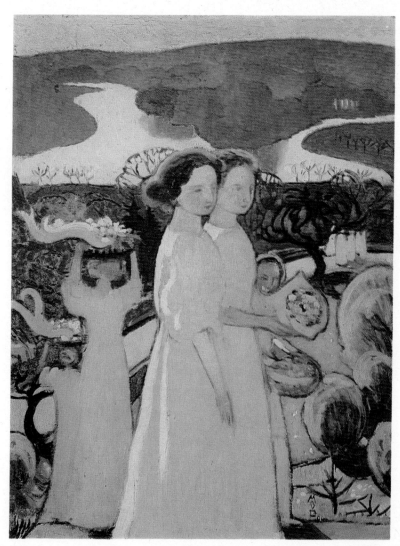

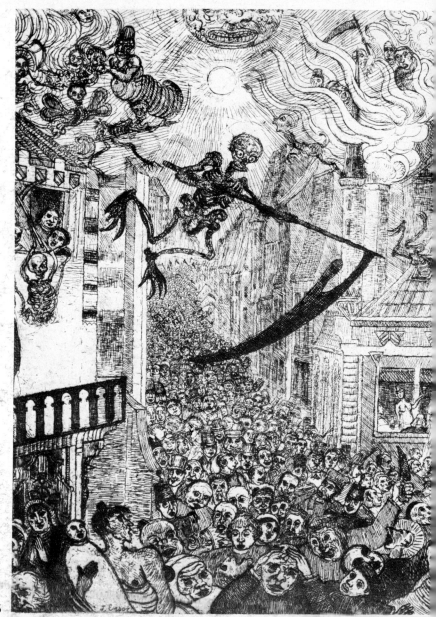

15

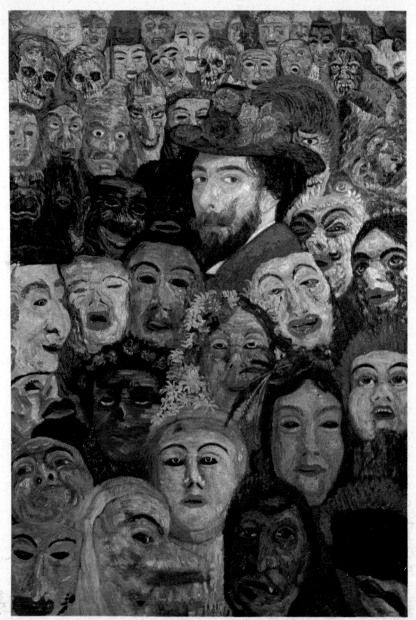

17

GAUGUIN

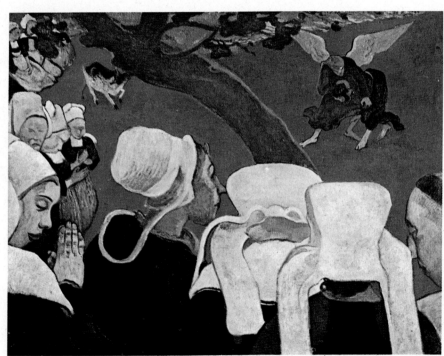

19

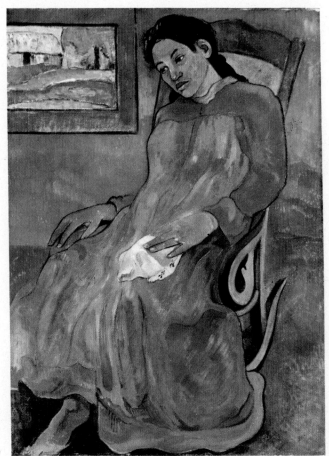

20

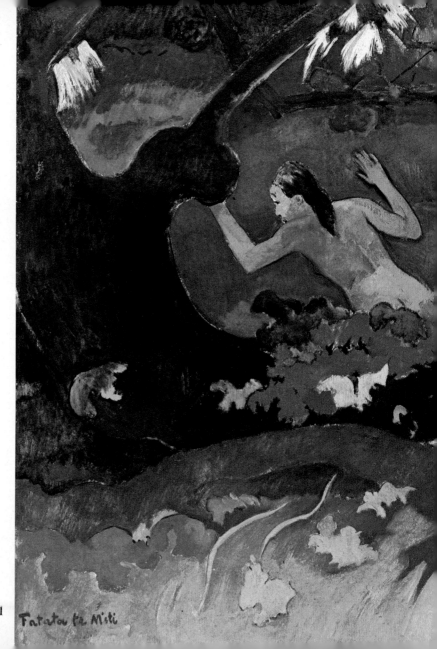

Tatatou te Miti

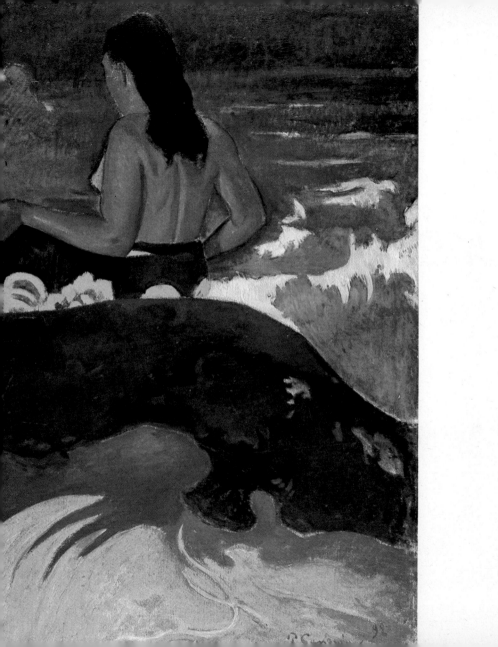

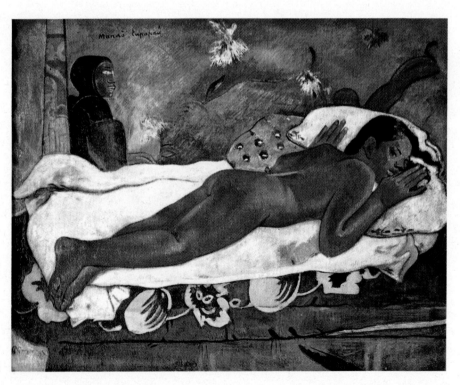

22

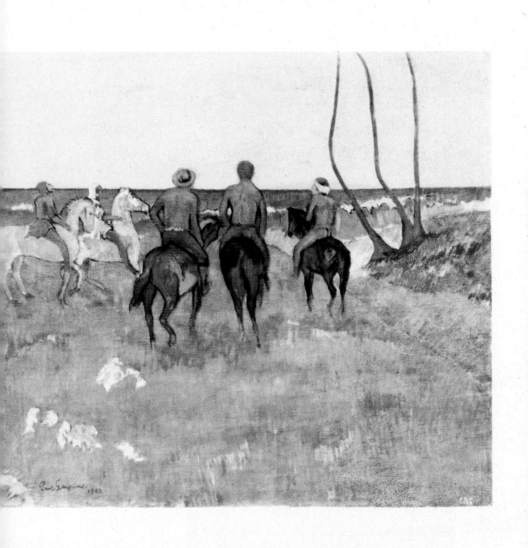

GRASSET

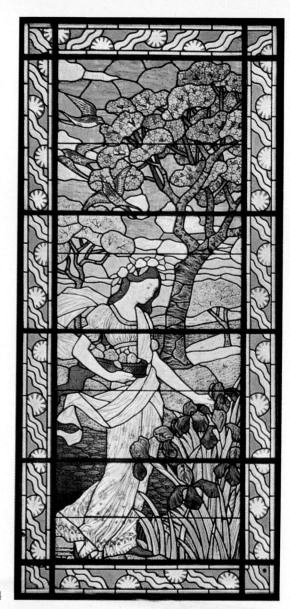

HODLER

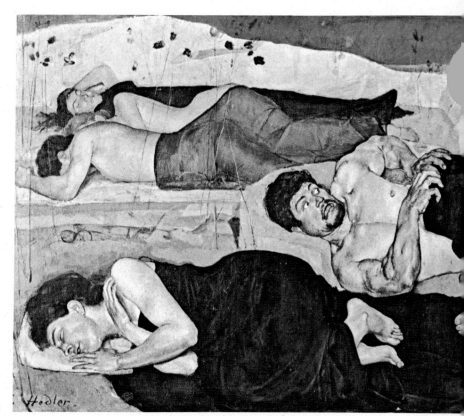

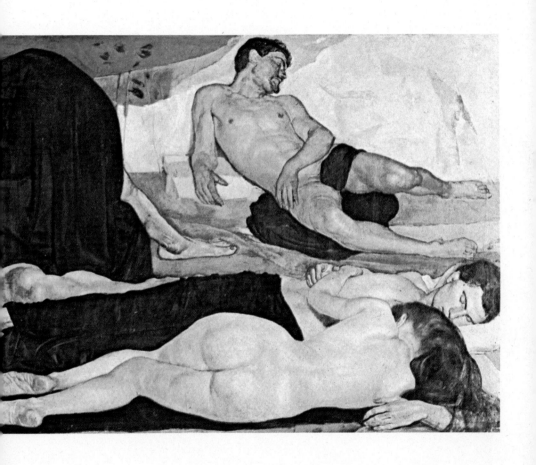

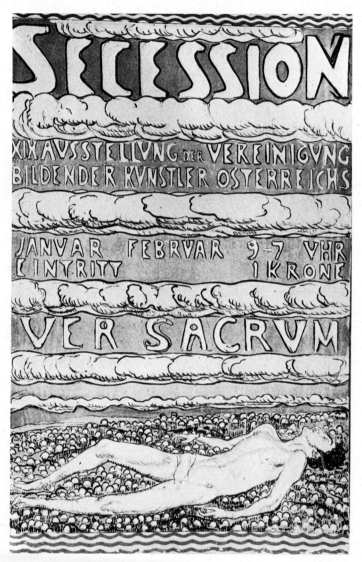

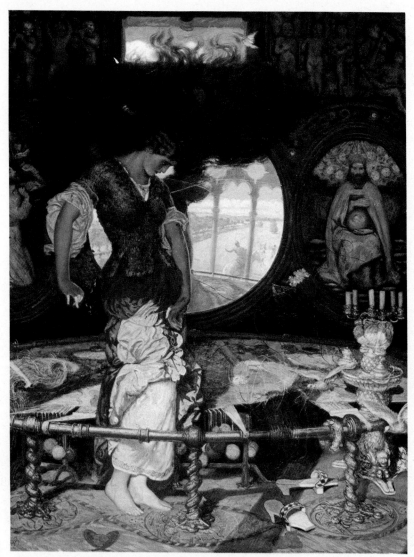

KELLER

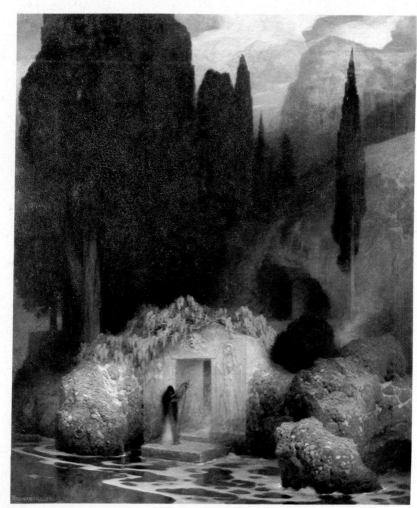

KHNOPFF

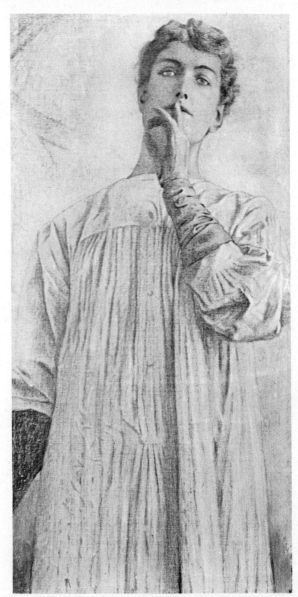

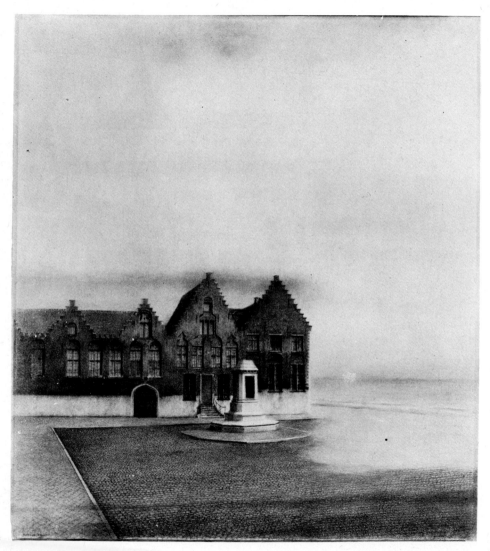

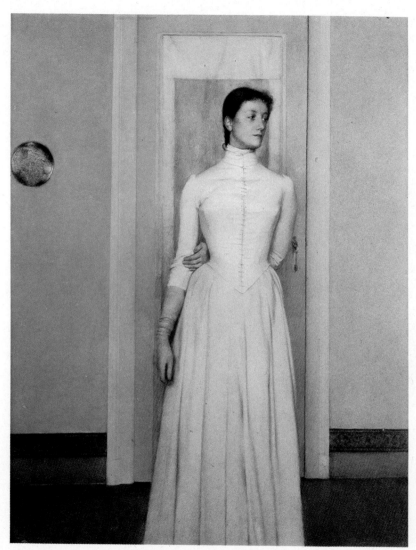

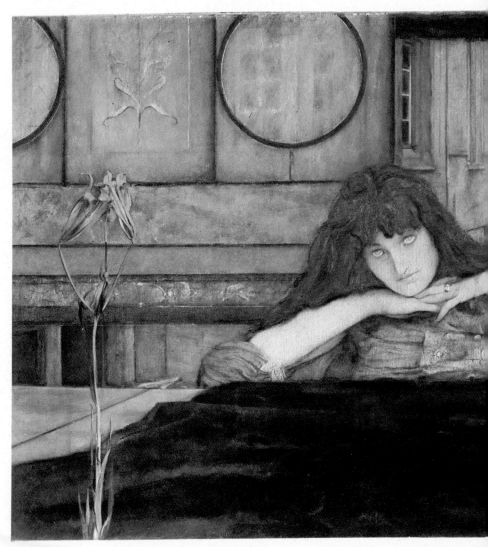

KLIMT

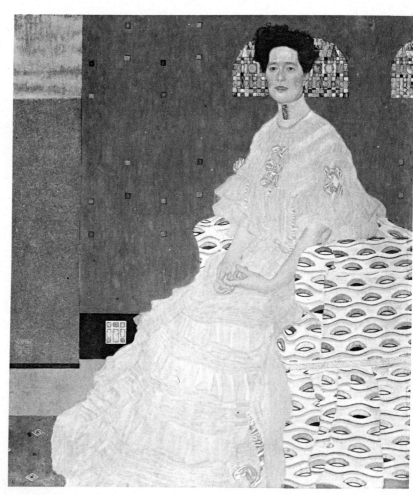

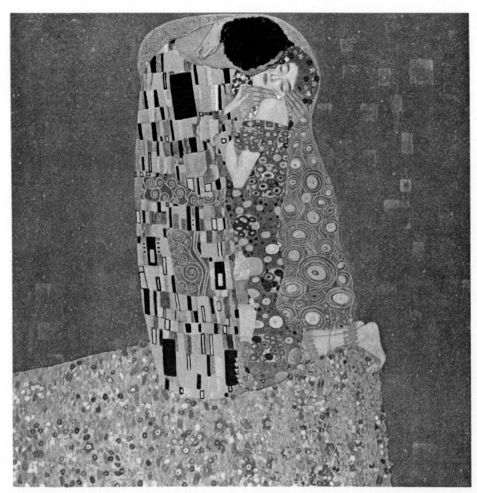

35

36

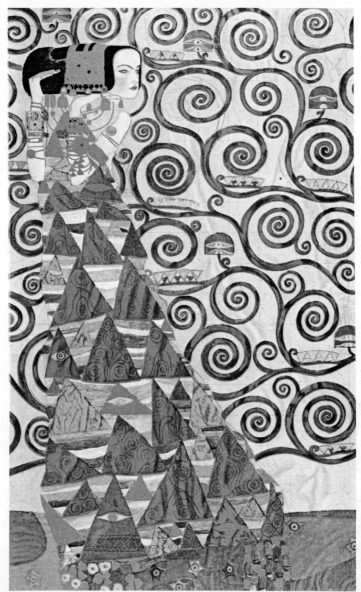

KLINGER

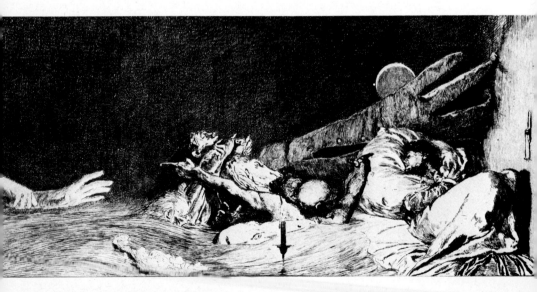

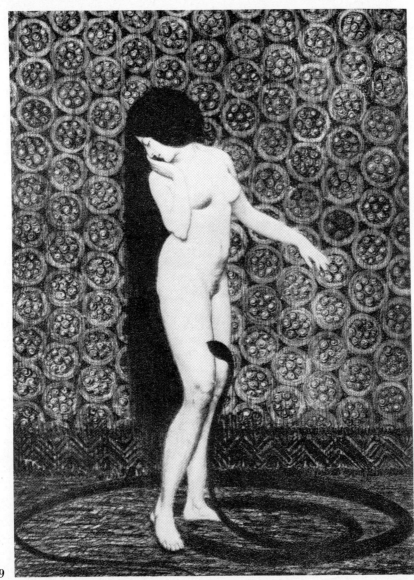

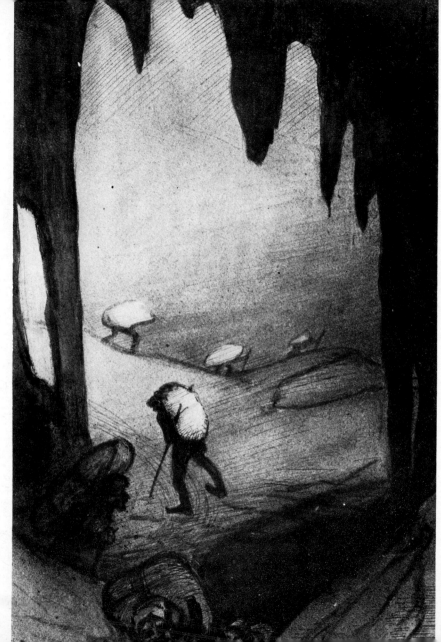

LÉVY-DHURMER

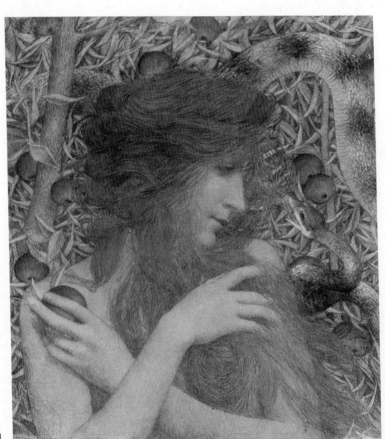

41

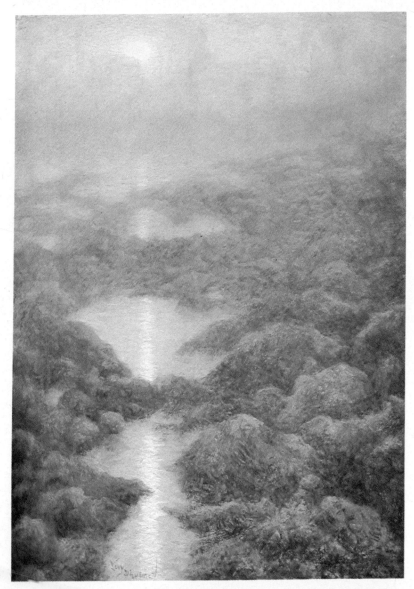

42

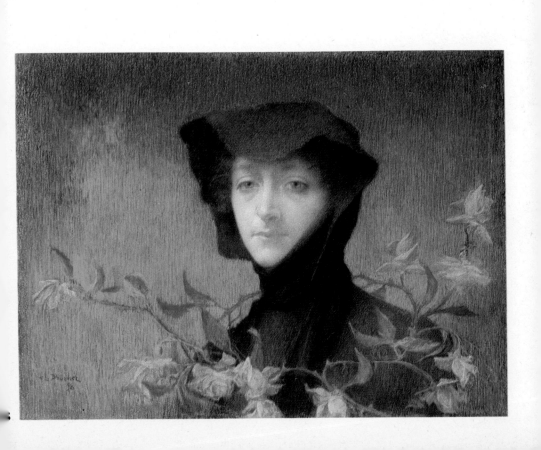

MAILLOL

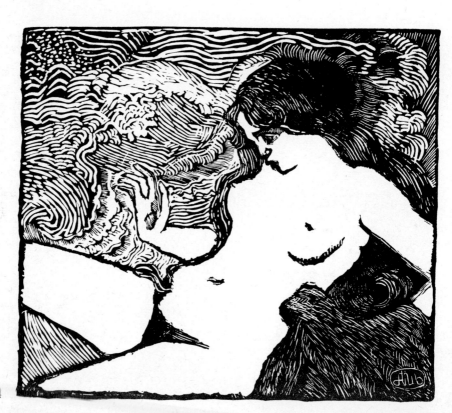

MARÉES

MILLAIS

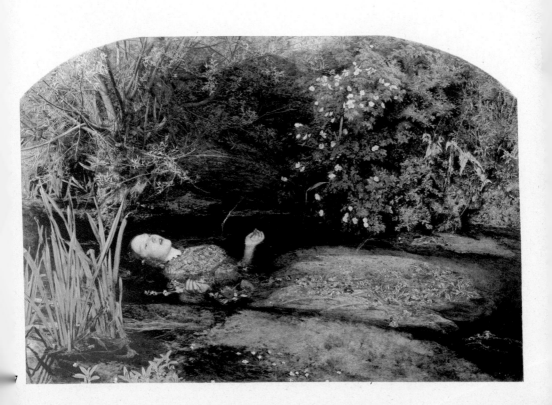

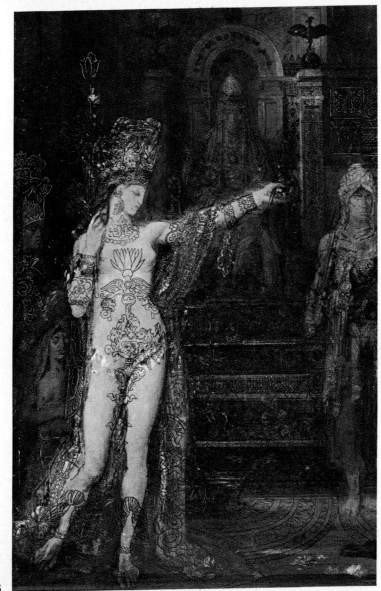

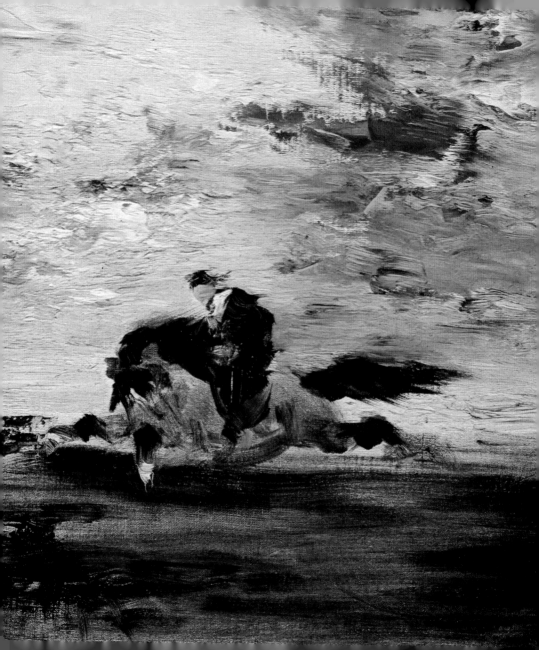

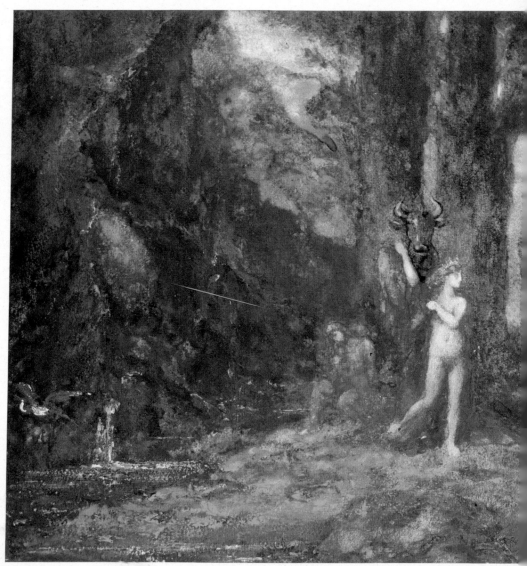

Gustave Moreau

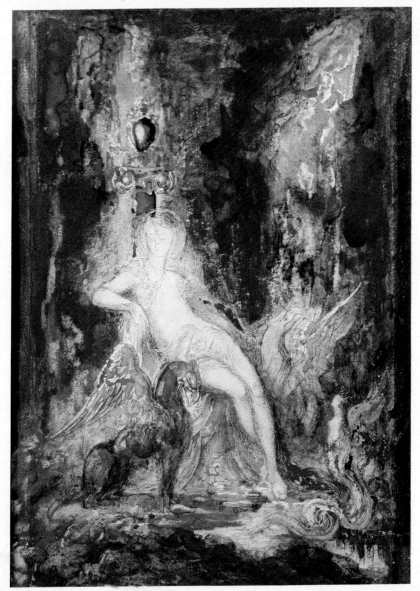

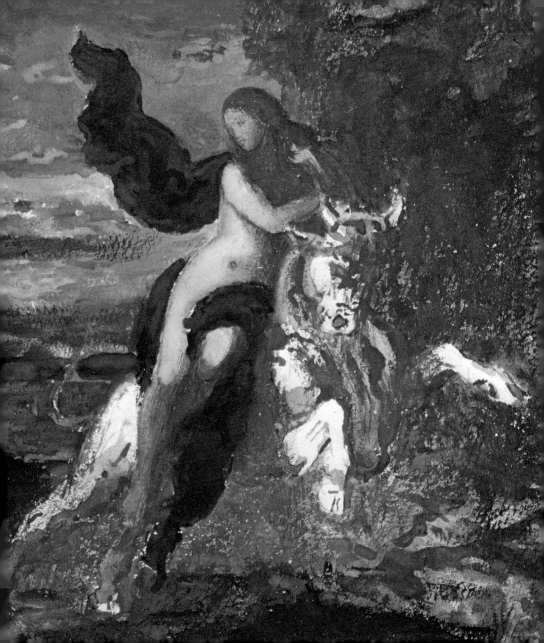

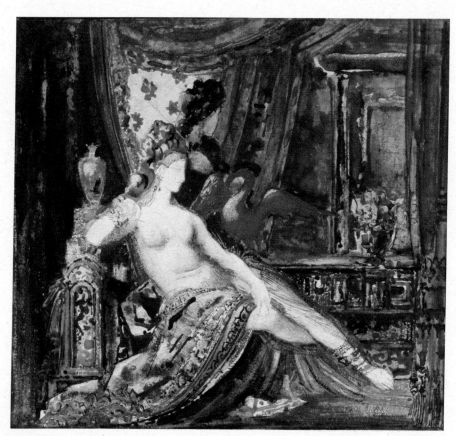

53

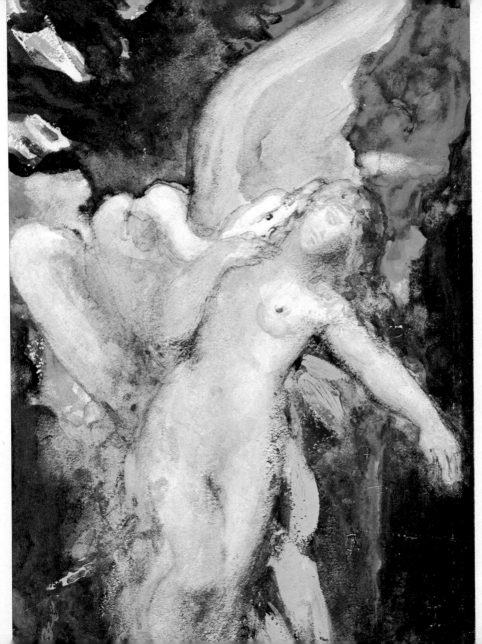

54

FRIENDS
IN NEED MEET
IN THE
WILD WOOD

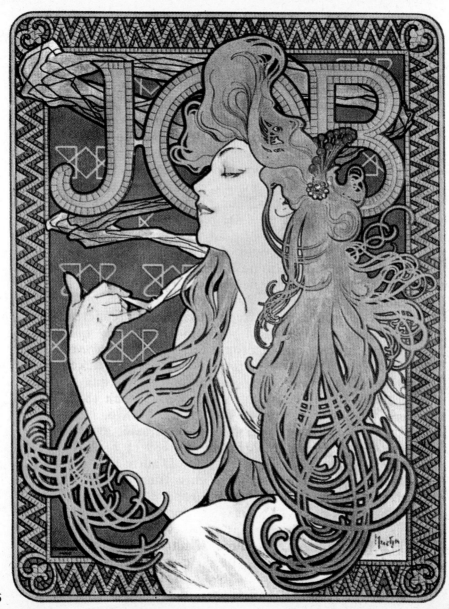

MUNCH

58

59

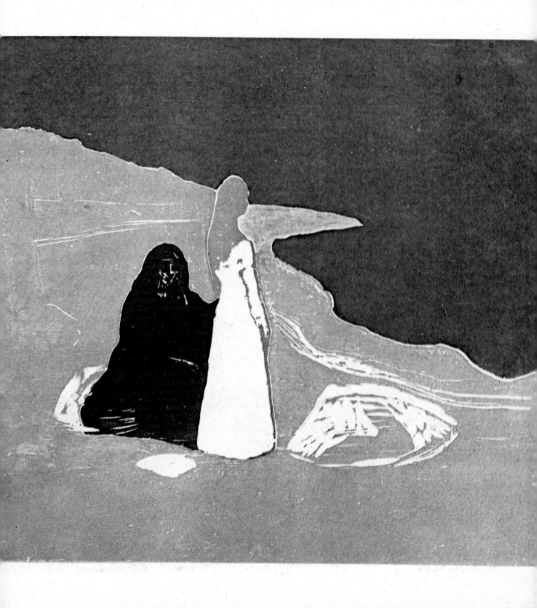

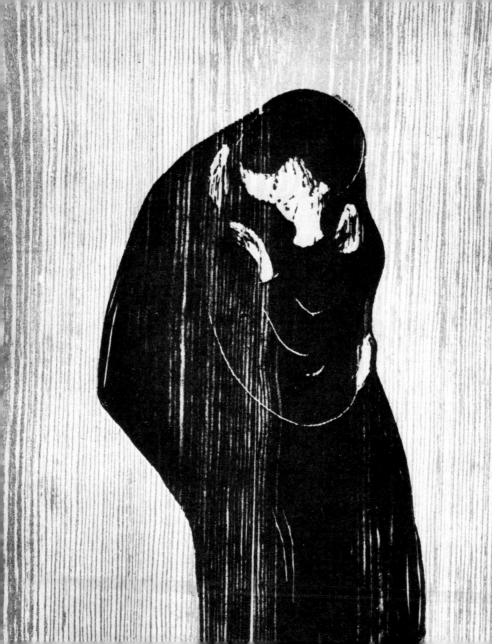

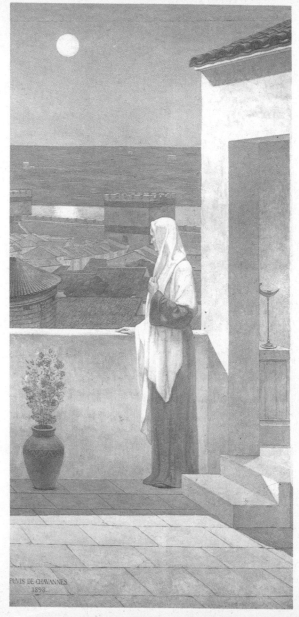

PUVIS DE CHAVANNES

63

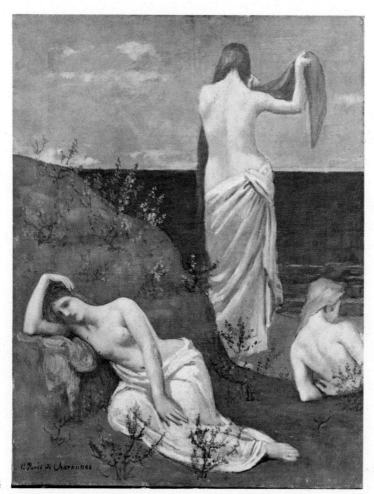

P. Puvis de Chavannes

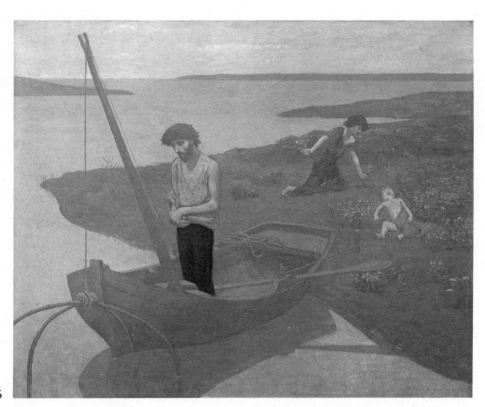

65

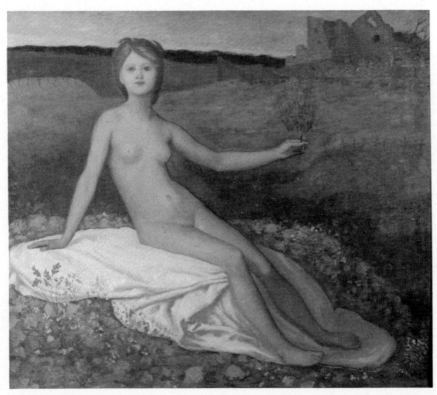

66

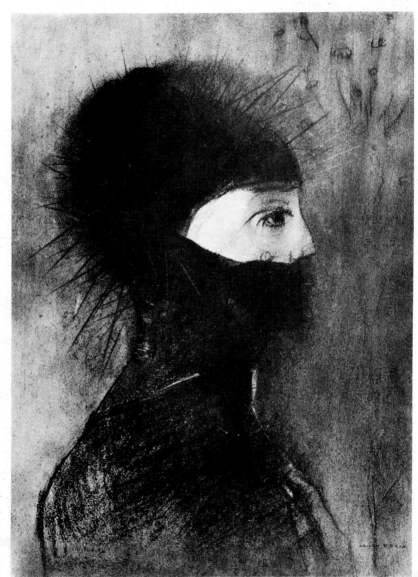

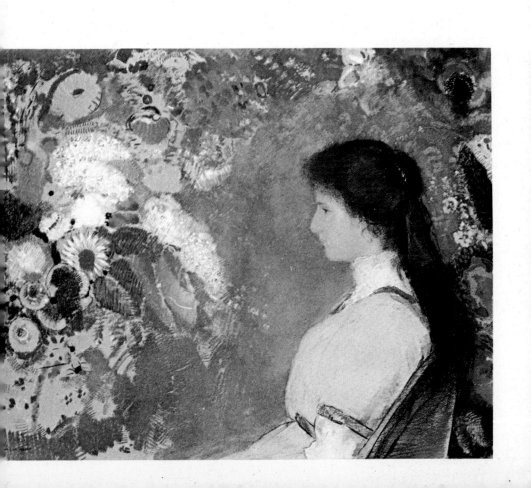

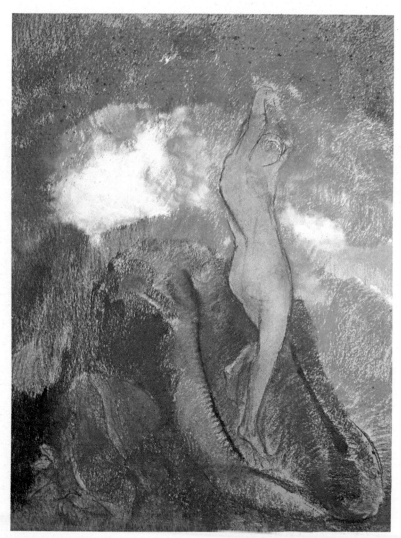

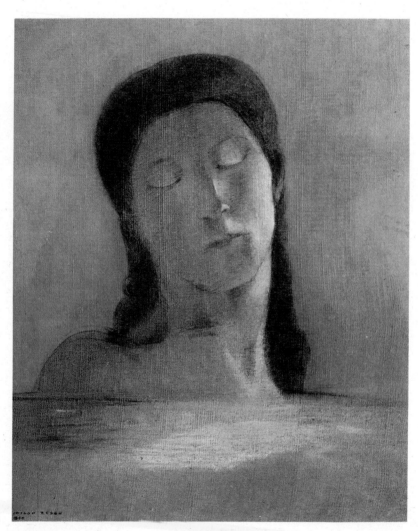

71

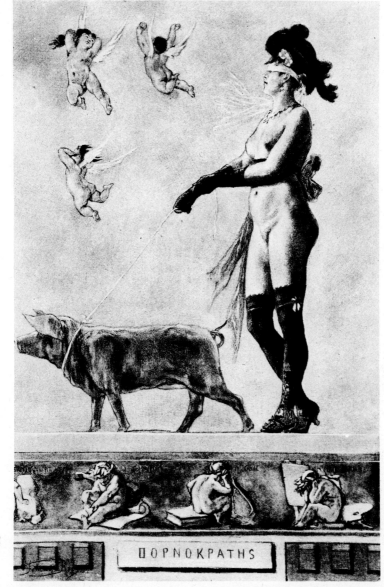

ΠΟΡΝΟΚΡΑΤΗΣ

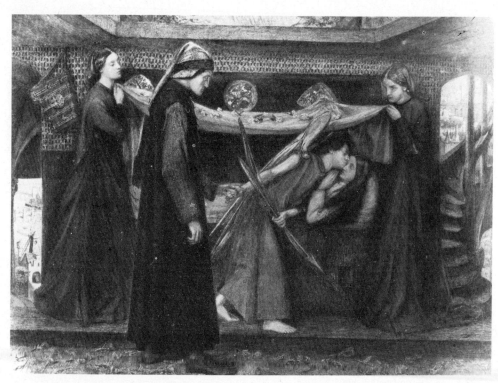

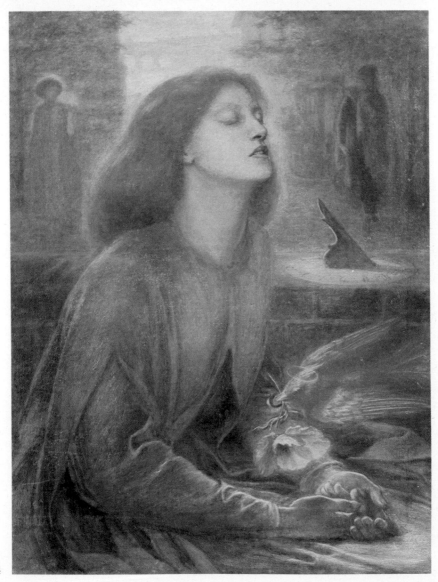

74

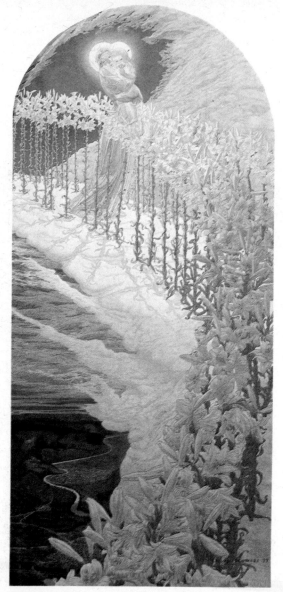

SCHWABE

SEGANTINI

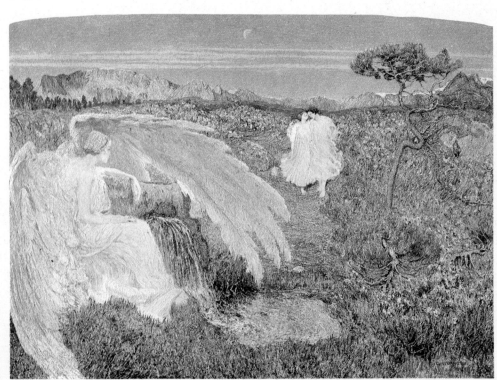

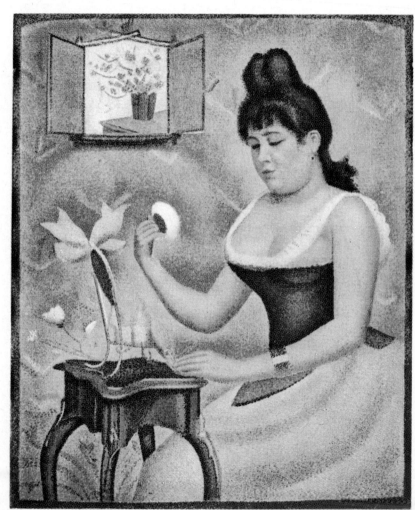

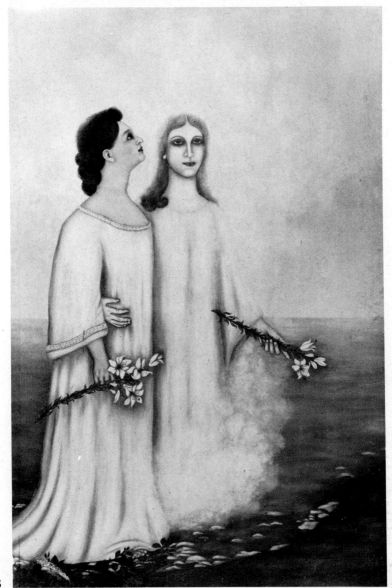

SPILLIAERT

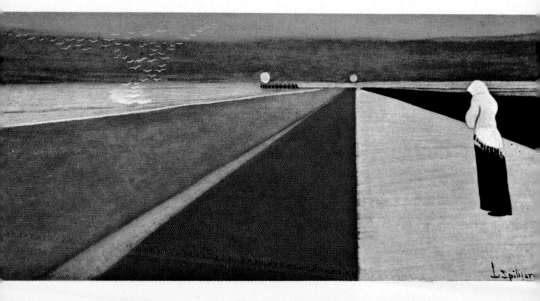

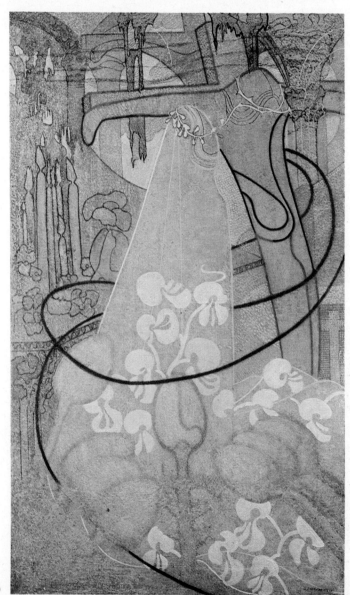

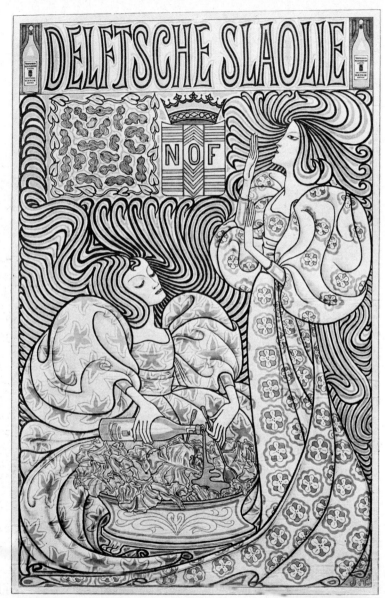

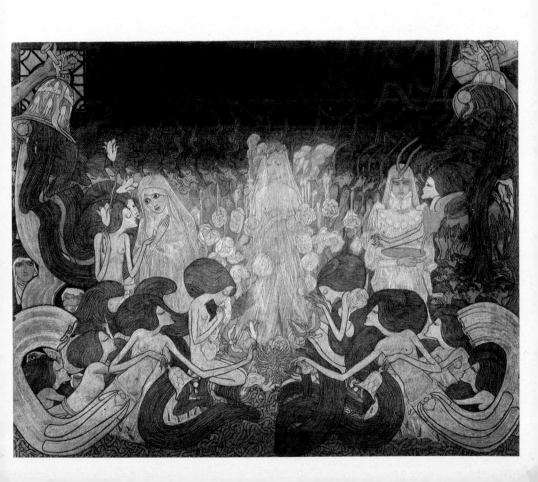

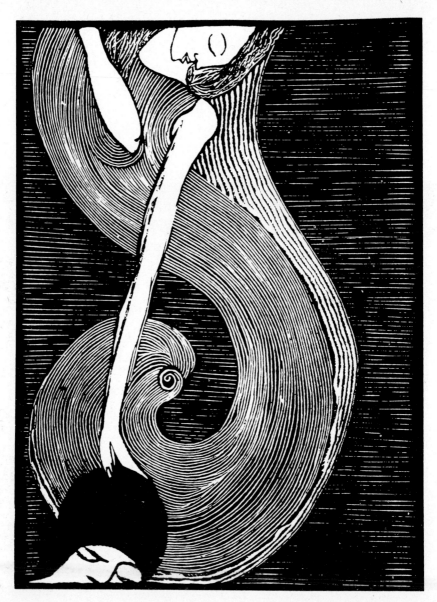

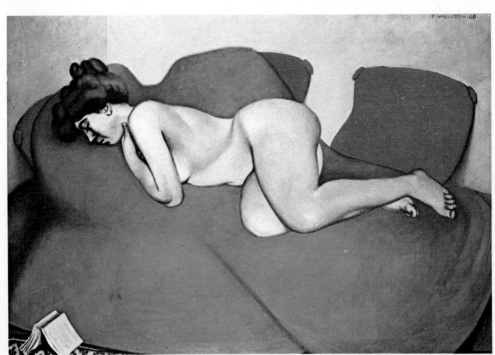

L'ASSASSINAT. FV

LA PARESSE

86

VROUBEL

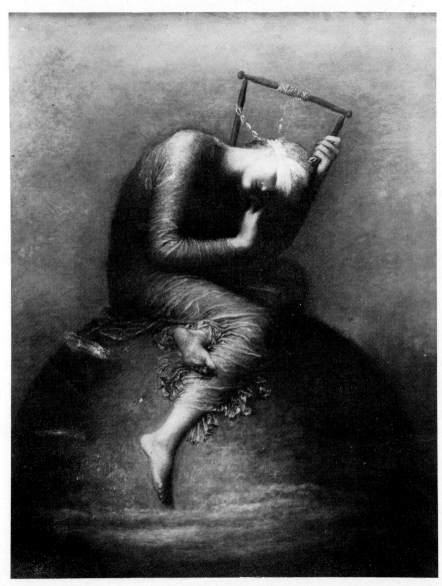

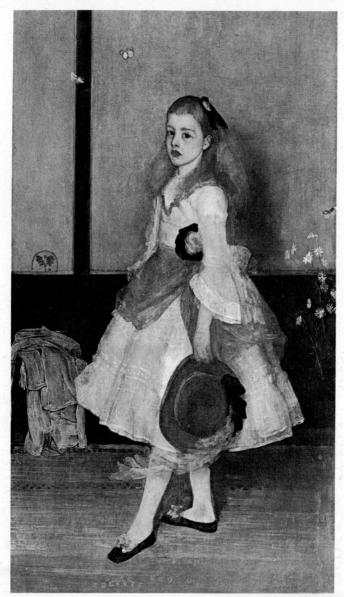

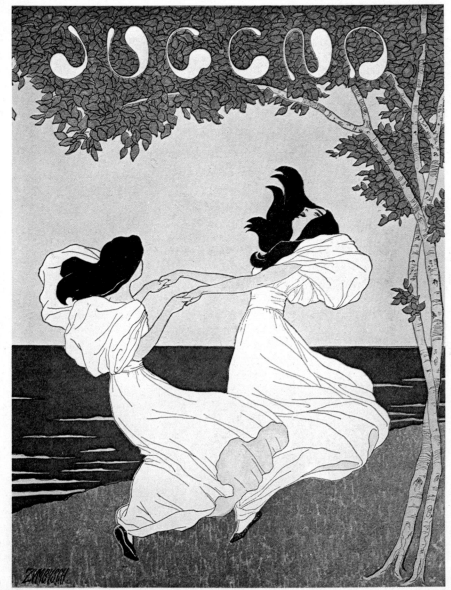

DUE

TED IN U.S.A.